IMAGES
of America

FORT THOMAS

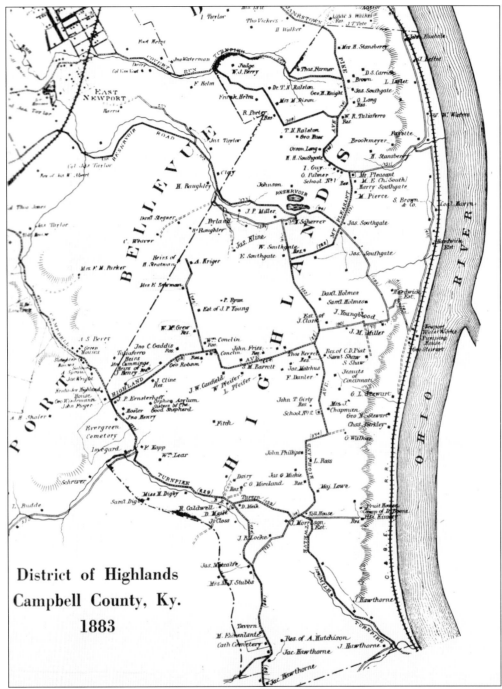

This 1883 map of the District of Highlands includes the name of every property owner in the rural farming community. The District of Highlands had no retail businesses in 1883.

ON THE COVER: This striking stone water tower marked the entrance to Fort Thomas, named in honor of Gen. George Thomas. The tower was constructed in 1890.

IMAGES
of America

FORT THOMAS

Bill Thomas

ARCADIA

Published by Arcadia Publishing
Charleston SC, Chicago IL, Portsmouth NH, San Francisco CA

Printed in the United States of America

Library of Congress Catalog Card Number: 2005938525

For all general information contact Arcadia Publishing at:
Telephone 843-853-2070
Fax 843-853-0044
E-mail sales@arcadiapublishing.com
For customer service and orders:
Toll-Free 1-888-313-2665

Visit us on the Internet at www.arcadiapublishing.com

*Dedicated to my three talented and beautiful children, Jennifer Alcala,
Katie Mills, and David Thomas*
—BT

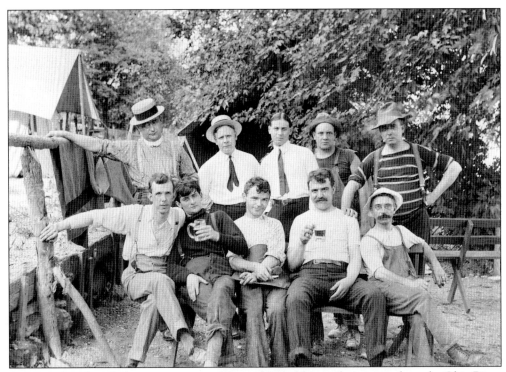

A group of unidentified young men enjoy beer and friendship at their camp along the Ohio River
in Fort Thomas. This photograph was taken in 1908. (Courtesy Peter Garrett.)

CONTENTS

ACKNOWLEDGMENTS

Many residents of Fort Thomas were grateful enough to assist the author in the compilation of photographs for this book. They include Dick and Jackie Thompson, Peter Garrett, Margaret Ross, Joyce Steinman, Ken Fecher, Rich and Sharon MacKnight, Jody Robinson, Jim Nedderman, and Mick Foellger. The author also wishes to thank the Campbell County Historical Society, Highlands High School, the City of Fort Thomas, Kenton County Public Library, and Behringer-Crawford Museum for generously providing access to their collections of photographs. This book would not have been possible without the computer skills and artistic eye of Carol Marnell, the author's business partner and friend. Carol scanned over 450 photographs and provided guidance and suggestions along the way.

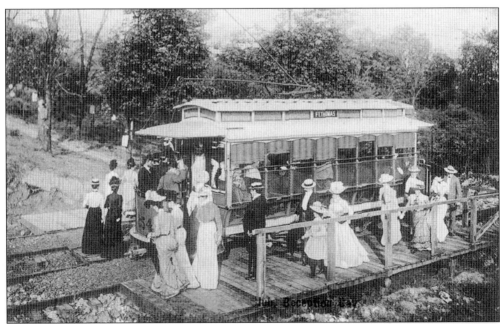

The streetcar arrives with guests for the grand opening of Inverness Country Club in 1900. The streetcar station would have been located on what is now Memorial Parkway. (Courtesy Ken Fecher.)

INTRODUCTION

Fort Thomas is a beautiful community situated high above the Ohio River in Northern Kentucky. The first permanent settlers were the Perry brothers, who arrived in 1788. Other settlers arrived in the early 19th century.

An old map of what is now Fort Thomas indicates that the famous frontiersman Simon Kenton once owned land here, and another map marks the location of Daniel Boone's camp on a bluff overlooking the Ohio River. There is evidence that prehistoric Native Americans once hunted here and constructed a burial mound on a hill overlooking the Ohio and Little Miami Rivers.

The oldest existing home in Fort Thomas was built in 1830 and is known as Mount Pleasant. The Taliaferro family arrived by flatboat and built the home with the help of 30 slaves. Mount Pleasant was used as the first church in town, and the Taliaferro family donated property for the rural community's first schoolhouse.

Many farms sprang up prior to the Civil War. The names of these early landowners included Southgate, Cline, McGrew, Girty, Hutchinson, Moreland, and Piatt. The 1860 census included a preacher, distiller, grocer, lumber dealer, florist, jeweler, and real-estate agents. Their businesses were in Newport or Cincinnati.

Fort Thomas was not a battle site during the Civil War, but landowners banded together to form a militia to protect themselves in case of Confederate attack. Battery Lee was located in what is now Tower Park, and another Union battery was constructed on a hill above Alexandria Pike. A larger fortification, Fort Whittlesey, was located at the corner of South Fort Thomas Avenue and Tower Place. Rifle pits were dug along Alexandria Pike and above River Road.

Henry Stanbery, Andrew Johnson's attorney general, was a resident of Fort Thomas and helped draft legislation that created the District of Highlands in 1867. Fort Thomas was known as the District of Highlands until 1914.

There were no retail businesses in the Highlands until Gen. Phil Sheridan chose a site overlooking the river in the south end of town as the location of a new military post that was to become the "West Point of the West." The arrival of the U.S. Army in 1887 brought with it a streetcar line and a new business district known as the Midway. The community experienced a surge of growth in the early 20th century.

Two stunning crimes rocked the community in the late 19th century. In 1879, Steve Klein was taken from the Newport jail by an angry mob from Fort Thomas and lynched without a trial from a tree near the corner of North Fort Thomas Avenue and Memorial Parkway. Klein was accused of assaulting and holding a woman against her will in her home on Water Works Road. Klein's crime caused an uproar in the Highlands, and his lynching resulted in an investigation by the governor and condemnation by the state's biggest newspapers.

The discovery of the headless body of Pearl Bryan in a farm field in 1896 brought national publicity to the Highlands. Two dental students from Cincinnati were arrested for her murder. They were found guilty and hung to death in Newport. Pearl Bryan's head was never found.

A second business district sprang up in the center of town around the City Building, which doubled as a school. A smaller business district, known as Inverness, developed along the streetcar line in the north end of town.

Fort Thomas schools are considered among the best in Kentucky both academically and athletically. Highlands High School has a rich history of academic excellence and athletic achievement, including a state-record 17 state football championships. Students at Highlands have also won state championships in swimming, tennis, cross-country, soccer, and track and field.

A number of one-room schoolhouses were eventually replaced by three public elementary schools and two parochial schools. Two of the elementary schools, Robert D. Johnson and Samuel Woodfill, were named in honor of Fort Thomas heroes who fought in World War I.

The military post has been converted into beautiful Tower Park. The old Mess Hall is now a community center, and the Armory is used as a recreation center.

Today Fort Thomas is a community of 16,600 with stately old homes and beautiful wooded hillsides.

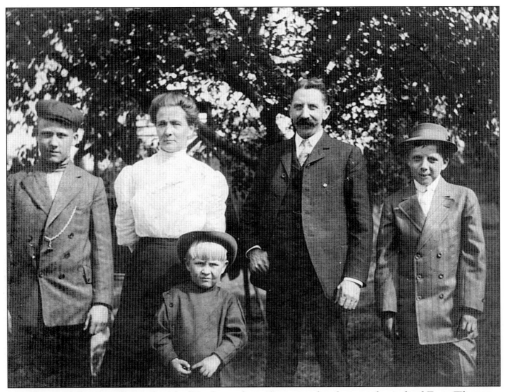

Members of the Landberg family lived on their farm in the far north end of Fort Thomas. (Courtesy Joyce Steinman.)

One

SCHOOLS

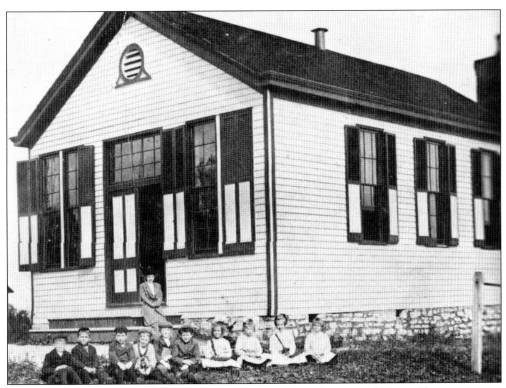

Inverness School was built in 1894 at the corner of Rosemont Avenue and Mount Pleasant Avenue (changed to North Fort Thomas Avenue in 1917). The one-room frame building included a coal stove for heat, a cistern, a coal shed, and two outhouses. There were eight students when the doors opened in 1894. Inverness School was closed in 1916. From 1916 until 1923, children in the north end of Fort Thomas attended Central School in the City Building. Robert D. Johnson School opened in 1923.

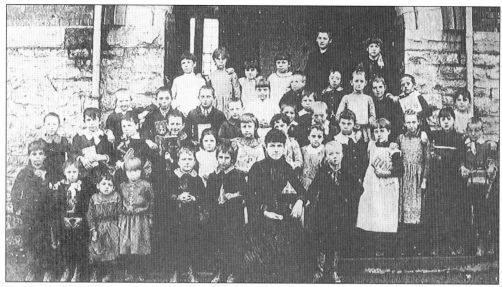

Teacher E. Taliaferro poses with her students at Highlands Central School in 1886. Highlands Central School opened in 1885, and classes were held in the City Building. Highlands High School took the place of Highlands Central School in 1888. Four students graduated from Highlands High School in the first graduating class of 1891.

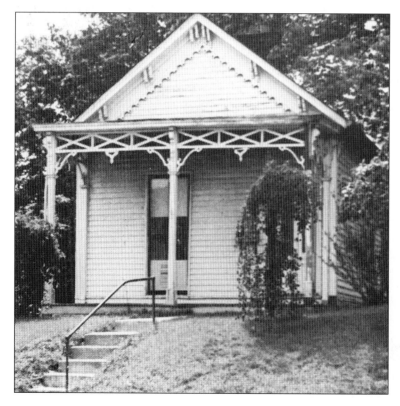

Known as Mount Vernon School, this small frame building across from Newman Avenue on Highland Avenue served as the only school in central Fort Thomas until the late 19th century. The school was built thanks to a donation by Captain Blackford of Carter's Lane. Mount Vernon had been the original name of the Highland Turnpike.

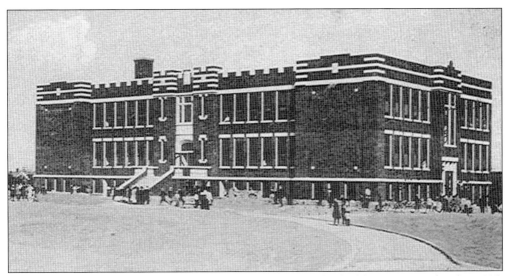

Highlands High School moved to its present location when this building was completed in 1915. Highlands played its first football game ever that fall. The *Altiora*, which was the school's first yearbook, and the *Highland Breeze* magazine were also published for the first time in 1915. This building was destroyed by fire in 1962. (Courtesy Ken Fecher.)

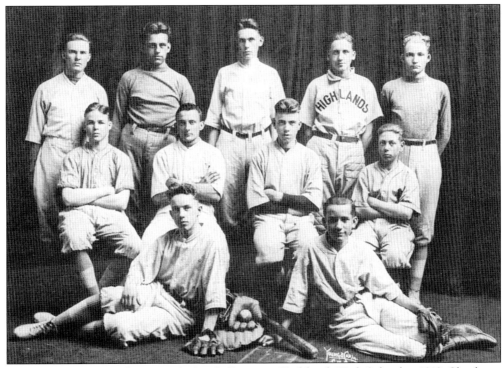

There were not many players on the baseball team at Highlands High School in 1918. Check out the size of the gloves used by players in those days.

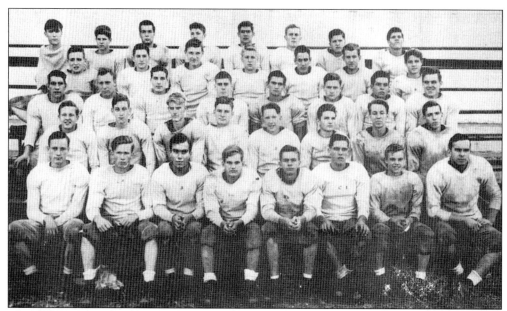

The 1942 football team at Highlands High School started the season with six consecutive shutout victories and won the Northern Kentucky Athletic Conference Championship. Team captains were Les Kyle and Jack Pogue.

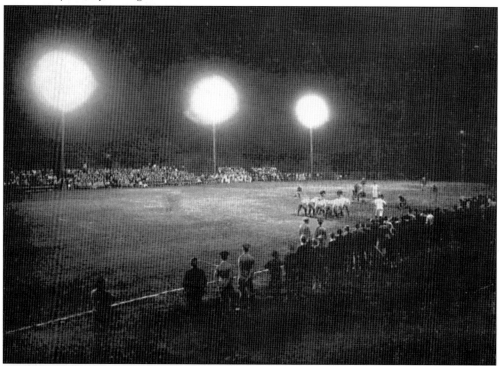

The Highlands football team performs under the lights in 1934. The field, located behind the school, had been reseeded that summer with the best turf available for athletic fields. The football schedule included Vanceburg, Terrace Park, Norwood, Ohio Military Institute, Bellevue, Ludlow, Erlanger, and Dayton.

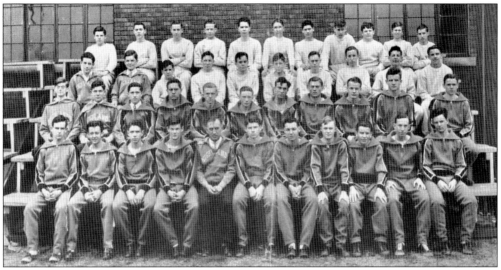

Members of the 1936 track team at Highlands High School pose for a team picture behind the school. The track team ran on a 330-yard cinder track for decades before the new track was constructed in Tower Park. The mile relay team won the state championship and never lost a race in 1936.

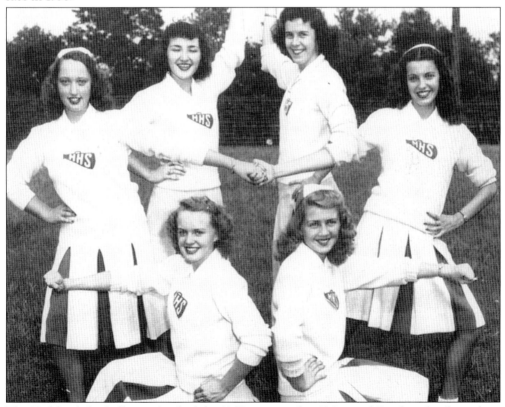

The Highlands football team finished the 1947 season with a 10-1 record. Leading the cheers from left to right were (kneeling) Ann Stolle and Janet Biltz; (standing) Marcia Keslar, Phyl Snyder, Joyce Huddleston, and Paulette Hasselbrink.

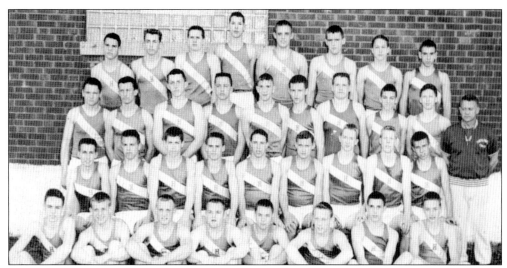

Highlands High School's track team captured the Kentucky state championship in 1959. It was the school's first state track championship. The coach of the team, Bernie Sadosky, had been Highlands' track coach since 1939.

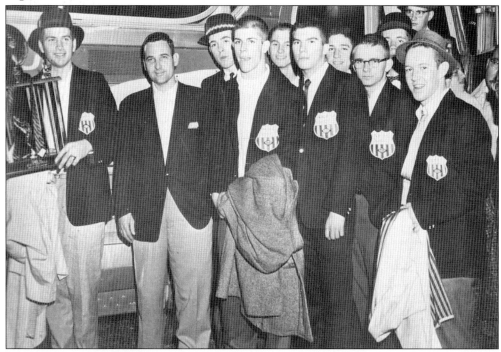

Legendary coach Homer Rice (second from left) arrives in Fort Thomas with the Highlands football team after capturing the school's first state playoff championship in 1960. Pictured with the trophy is Bob Steinhauser. Bill Gibson, wearing a hat, is third from the left. Other players include from left to right (first row) Joe Ross, Jack Gish, Roger Walz (glasses), and Jim Borches (hat). The 1960 team beat Bowling Green (the best team in the West), Louisville Male (the best team in Louisville), and Ashland (the best team in the East). Rice went on to coach Rice University, the University of Cincinnati, and the Cincinnati Bengals. He also served as athletic director at North Carolina and Georgia Tech.

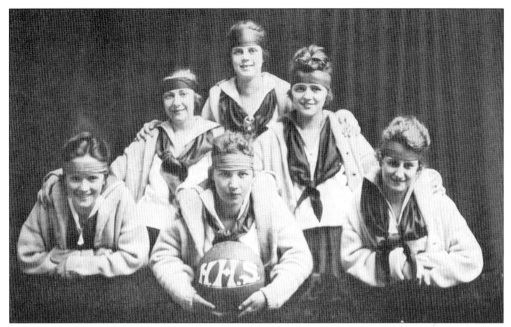

The 1917–1918 girls' basketball team at Highlands High School had a tough season that included a 28-2 whipping by Norwood. The girls' basketball team played with the same rules as the boys' team in those days. Years later, the rules were changed to restrict girls' play because state athletic officials were concerned that the girls were acting too much like boys.

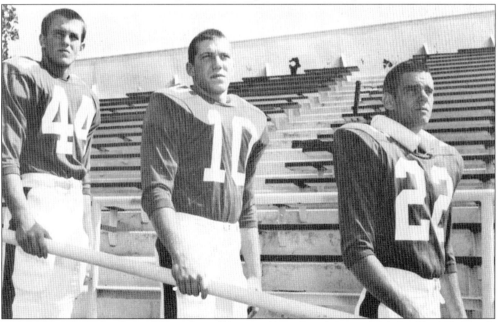

Rick Hoffman, Tim Racke, and Clem Fennell (pictured here from left to right) helped lead Highlands to an undefeated season and Class AA state championship in football in 1968. Highlands has won a state-record 17 state football championships since the playoff system began in 1959. Hoffman went on to play running back and receiver at Indiana University; Racke played defensive back at Purdue University; and Fennell punted for the University of Cincinnati.

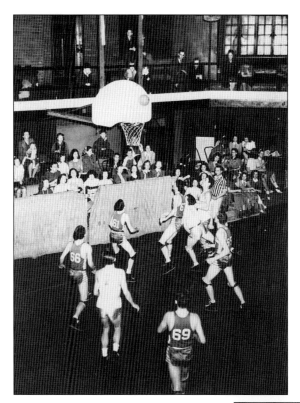

Highlands used to play varsity basketball games in a small gym with a balcony for fans. The gym is still used by physical education classes, but the balcony has been removed. A new gymnasium was added to the school in 1956. (Courtesy Ray Duff.)

Homer Jackson, Highlands High School's football coach in 1930, led the Birds to an undefeated season and Greater Cincinnati championship. John Hosking and Bill Fleming were named All State and All Cincinnati. Captain Bob Stegeman also made the All-Cincinnati Team.

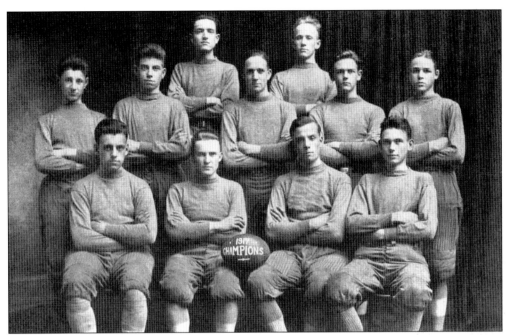

The 1917 football team at Highlands High School began the football tradition of excellence at Highlands. The team finished the season with a 6-3 record and was crowned champions of Northern Kentucky. The team's nickname was the Blue Devils until the late 1920s, when all teams at Highlands took on the name Bluebirds.

Sports captains during the 1957–1958 school year at Highlands High School included from left to right: (kneeling) Bob Goes, swimming; Dick Smoot, baseball; Gary Cochran, football and track; (standing) Kenny Glass, swimming; Denny McAtee, basketball and golf; and Jerry McAtee, track.

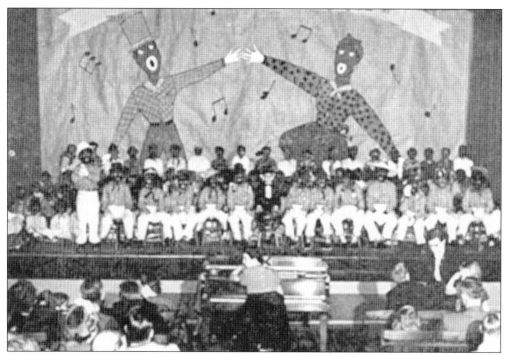

This is a scene from a minstrel show performed by intermediate grades at the annual PTA program at Ruth Moyer School in 1952. The children were enthusiastic, and the show was well received. Highlands High School performed minstrel shows every other year in the 1950s and early 1960s with black-faced performers under the direction of music teacher Robert Knauf.

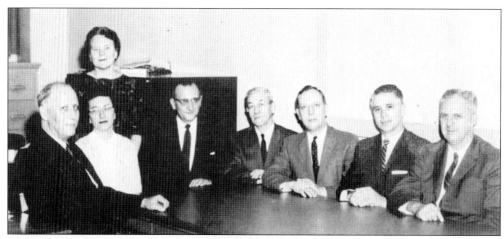

The Fort Thomas Board of Education and administrative staff worked long hours in 1962 after a fire destroyed one of the classroom buildings at Highlands High School. Pictured from left to right are (seated) Ewell Waddell, Betty Spradlin, Alvin Miller, Gerald Cecil, Robert Raisbeck, Robert Grimm, and Robert Evans; (standing) Alice Anderson.

Louella Greeno began teaching home economics at Highlands High School in 1933. She received a degree in home economics from the University of Kentucky in 1929 and also taught at Cass Township High School. Louella Greeno taught home economics at Highlands for four decades.

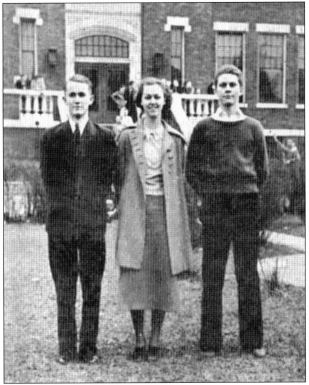

These three students served as officers of the 1937 senior class at Highlands High School. Tom Pulliam (left) was president of the class, Jane Petty (center) served as class secretary, and Dick Disney served as class vice president. The 1937 class at Highlands was the biggest to date with 90 students. The class of 1938 was the first graduating class with more than 100 students.

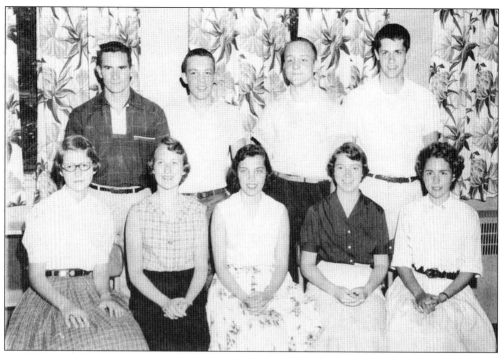

College scholarship winners from the 1958 senior class at Highlands High School included from left to right: (seated) Karen Sturdy, Judy Gaines, Marjorie Hamilton, Ann Kuehner, and Linda Challis; (standing) Doug Martin, Alan Anderson, Elwyn Berlekamp, and William Waddell.

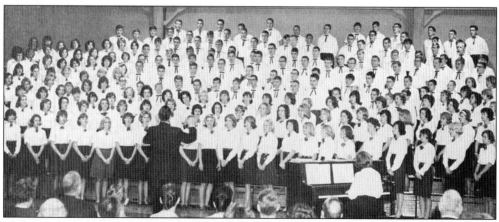

The senior chorus at Highlands High School performs under the director of music teacher Robert Knauf in 1965. The most important concert of the year took place in March with the Cincinnati Symphony Orchestra in the high school gymnasium. Knauf passed away in January 2006.

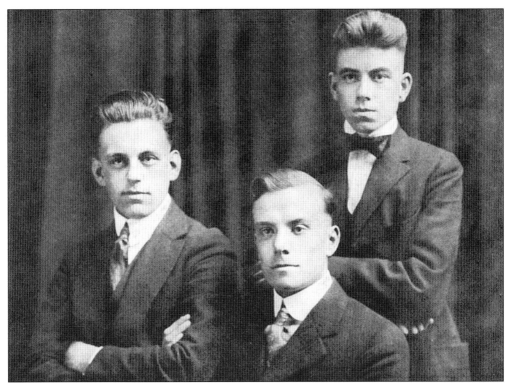

Senior class officers at Highlands High School in 1918 pictured here from left to right are Randall Stegeman, Earl Barr, and William Cargill.

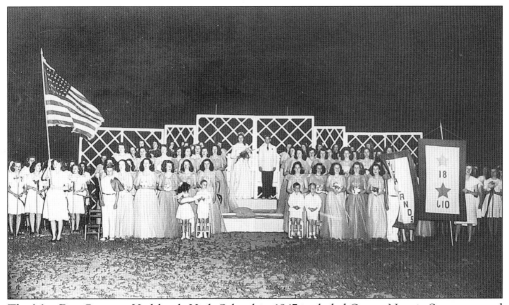

The May Day Court at Highlands High School in 1947 included Queen Nornie Stegeman and King Dick Thompson. (Courtesy Campbell County Historic Society.)

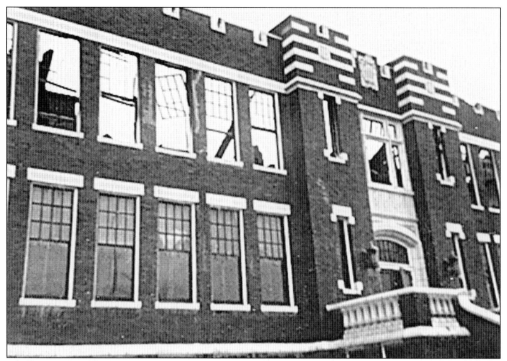

The interior of Highlands High School was completely destroyed by a fire on a cold, snowy night in 1962. No one was injured, and a new junior-high school building was constructed in its place and opened in September 1963.

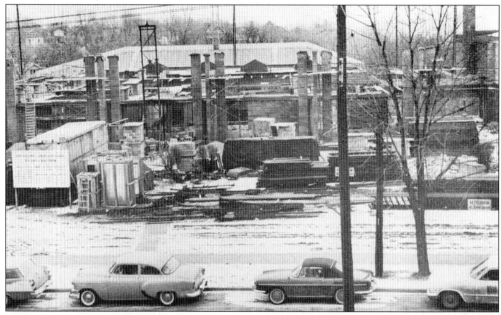

The middle building at Highlands High School was rebuilt in 1962 after fire destroyed the original building. Students took classes in various locations throughout town during construction, including Highland United Methodist Church and First Baptist Church. This photograph was taken from Highland United Methodist Church.

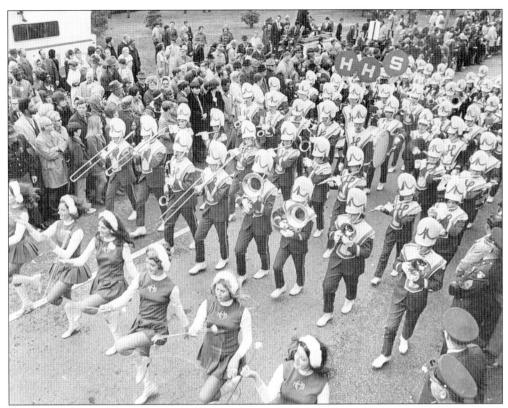

Highlands High School's marching band performs in a parade in 1970. (Courtesy Kenton County Public Library.)

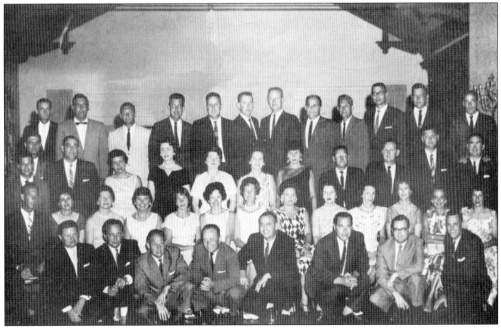

The Highlands High School Class of 1942 poses for a class picture at its 20-year reunion in 1962.

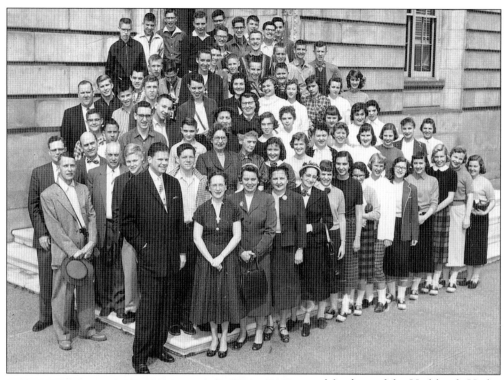

Members of the Highlands High School band pose with U.S. Senator Thurston B. Morton of Kentucky in the late 1950s.

Maude Brown served as a nurse in the Fort Thomas school system for half a century. Jean Stivers can be seen standing in the background of this photograph taken at the Fort Thomas Bicentennial Celebration in 1967.

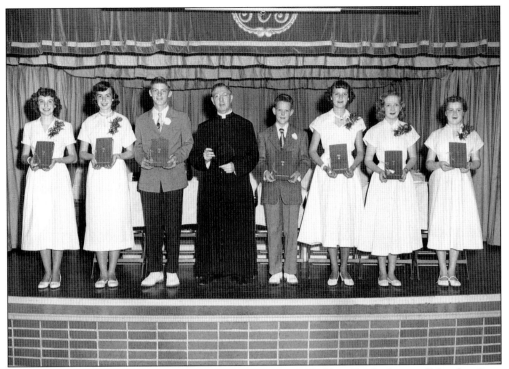

Students line up for the second graduation ceremony ever held at St. Catherine School in June 1952. From left to right, they are Nancy Breitenstein, Judith Ludwig, John Bankemper, Father John McCrystal, Fred Fischer, Elaine Olberding, Sue Corbett, and Joyce Grupp.

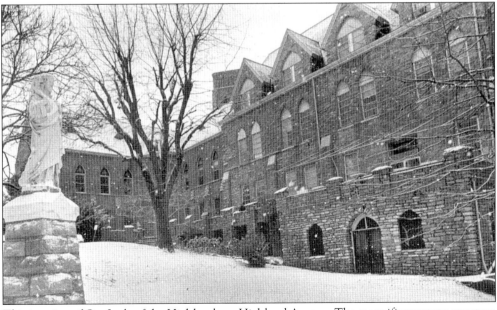

This is a view of Our Lady of the Highlands on Highland Avenue. The magnificent stone structure was used as an orphanage and school for Catholic girls for over a century.

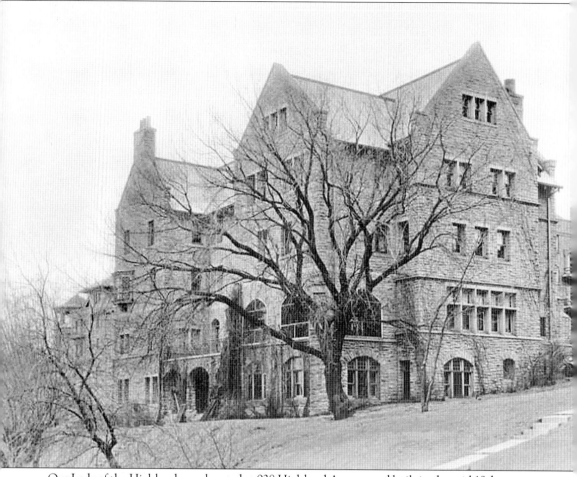

Our Lady of the Highlands was located at 938 Highland Avenue and built in the mid-19th century. An 1883 map of the Highlands describes the school as an orphan asylum operated by the Sisters of the Good Shepherd. The beautiful building was torn down to make way for the Highlands of Fort Thomas nursing home.

Two

CITY GOVERNMENT

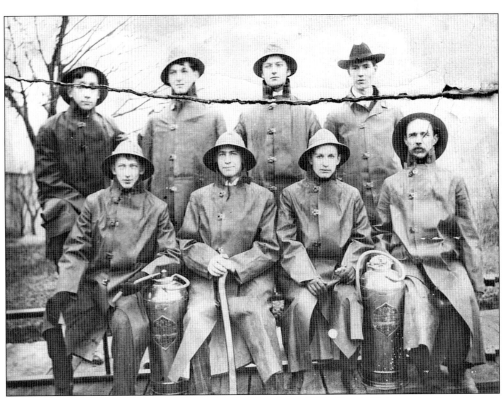

The volunteer fire department served the Highlands in 1908. Frank Phister, the first chief, is seated at left. Earl Metcalfe, a silent screen movie star, is seated next to Phister. Others from left to right include Sam Hills and William White on the first row and Ray Voige, Fred and June Wilson, and Walter Jones on the second row.

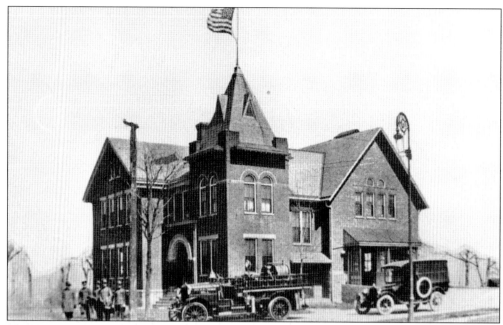

This is an early photograph of the City Building, built in the 19th century. Note the fire truck and the beautiful, ornate light pole in front of the automobile.

Pictured here is the City Building in 1960. It housed the police and fire departments, the city jail, police court, administrative offices, and city council chamber.

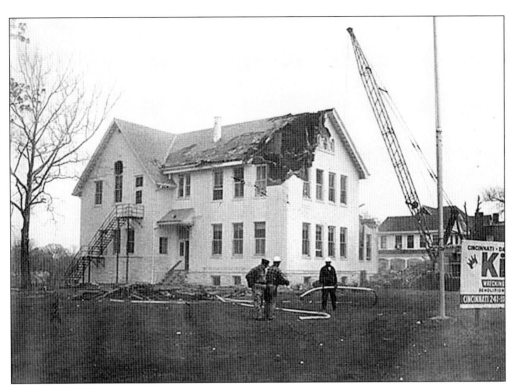

The original City Building was demolished in 1966 to make way for the current City Building on North Fort Thomas Avenue. Many children went to school in the original City Building before Highlands High School moved to its new building in 1915.

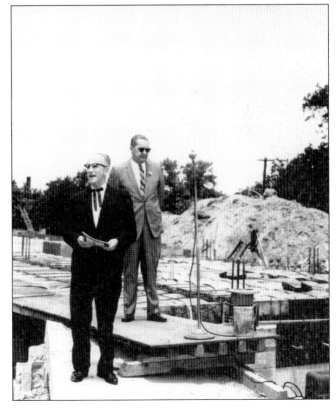

The new Fort Thomas City Building was under construction in 1966. Charlie Kuhn (in dark suit) was Fort Thomas city engineer and city coordinator for over 40 years. (Courtesy Dick Thompson.)

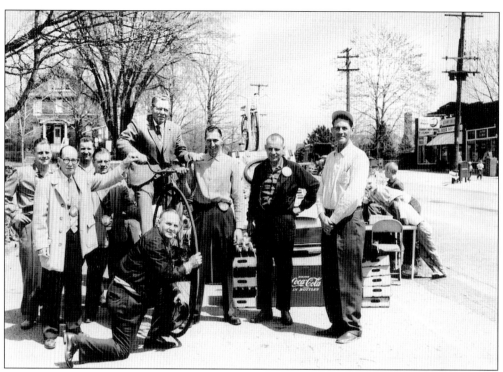

Members of the Fort Thomas Optimist Club support Mayor Donaldson Brown on an antique bicycle on South Fort Thomas Avenue. (Courtesy Ray Duff.)

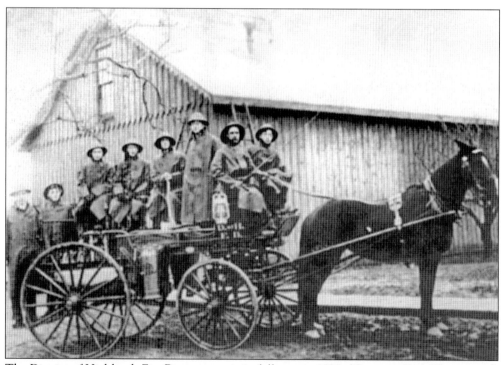

The District of Highlands Fire Department is in full gear in 1890. (Courtesy Dick Thompson.)

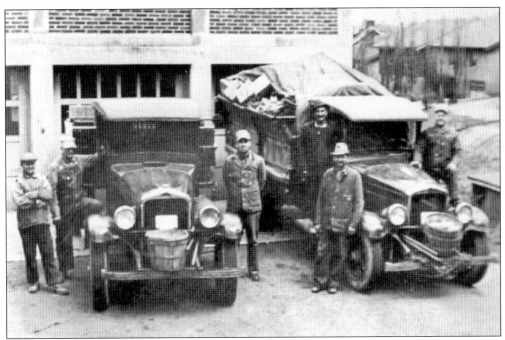

Employees of the city sanitation department pose with their trucks at the City Building in 1948.

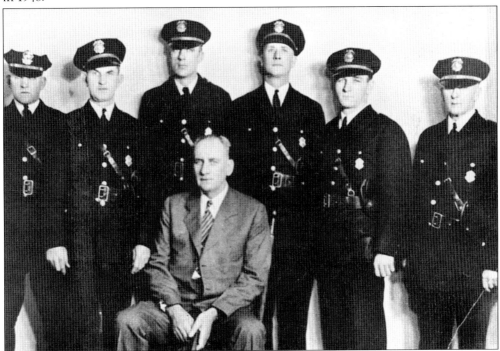

Members of the Fort Thomas Police Department stand next to a seated Chief Louis W. Cook. The police officers from left to right are Harrison Herms, Charles Bahlman, Ernest Clark, Frank Strubbe, Albert Terney, and Amos Ross. Chief Louis W. Cook went to work for the city in 1908 and was appointed police chief in 1921. He retired in 1955. (Courtesy Dick Thompson.)

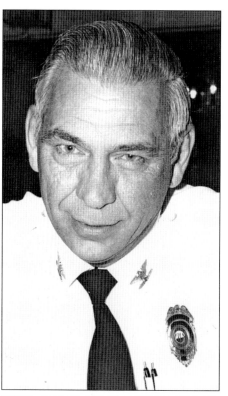

Police Chief Dick Quehl served the city after the retirement of Louis Cook. This picture was taken in 1986. Chief Quehl started with the city in 1932 as a sub-patrolman. In 1967, he supervised the department, which had 16 regular police officers and five cruisers. (Courtesy Kenton County Public Library.)

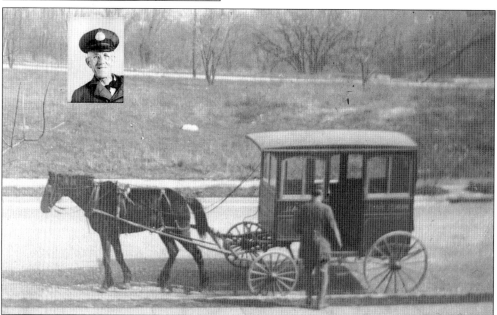

James Edwin MacKnight can be seen in front of his house at 78 Miller Lane in 1921. MacKnight delivered the mail in Fort Thomas with his horse and carriage. He eventually had to walk his route after the city got rid of his horse. MacKnight delivered mail in Fort Thomas from 1919 until the day he retired. He died in 1973. One of his children, Harry, was Fort Thomas treasurer from 1953 to 1982. (Courtesy Rich and Sharon MacKnight.)

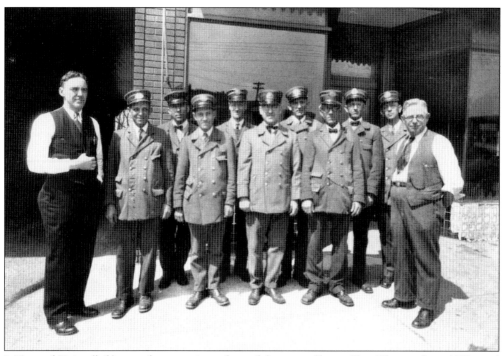

J. Howard Voige (left) served as superintendent of the post office in Fort Thomas from 1911 until 1947. Later he served as superintendent of the Newport post office.

The old city dump used to be located on River Road. The site is now a small baseball field. (Courtesy Dick Thompson.)

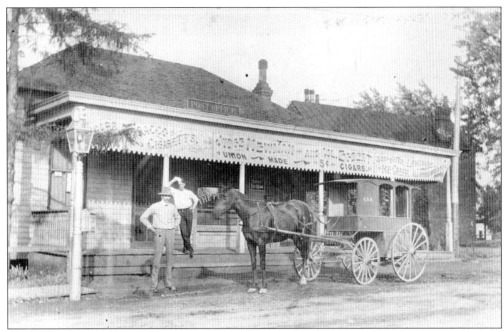

The post office and Judge Newman and Col. Egbert Confectionary/Cigar Store were located just north of the military post on property owned by L. L. Ross (now 802 South Fort Thomas Avenue). The store sold 5¢ cigars, cigarettes, ice cream, and soda water.

An unidentified man carries his friend on his shoulders in this photograph of the grocery store and post office in the Dale section of the Highlands in 1900. Dale was the name used by residents of Grant Street and other nearby streets in the south end of the Highlands. Dale Street is located behind Woodfill School.

Three

HISTORIC HOMES

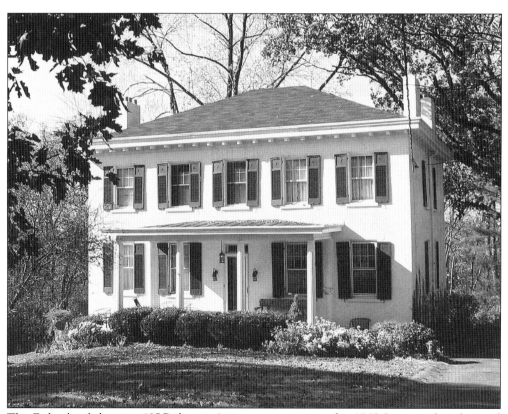

This Federal-style home at 185 Ridgeway Avenue was constructed in 1865. It was used as a hospital during or shortly after the Civil War and was also owned by Judge Helmes, the judge in the Pearl Bryan murder case in 1896.

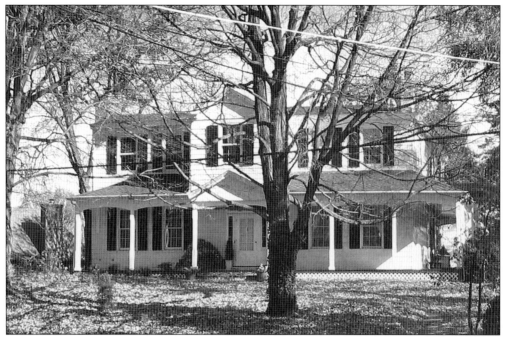

This house at 1810 North Fort Thomas Avenue is the oldest in Fort Thomas and was built in 1830 by the Taliaferro family. It was originally a log cabin and has been added onto over the years. This Southern-style home probably had two rooms on the first floor and two rooms on the second floor separated by a hallway. The original kitchen was in a separate building behind the house. Slave quarters and the barn were also behind the house.

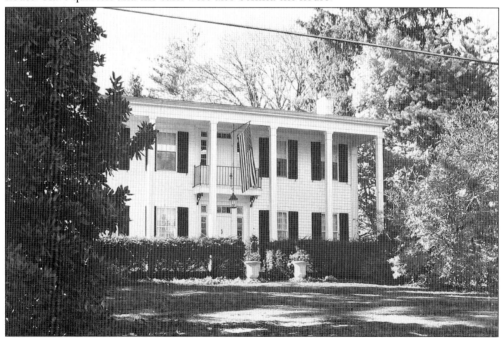

This home at 2103 North Fort Thomas Avenue was built in 1840 and was constructed in the Greek Revival style. It was remodeled after World War II to give it a Southern Colonial look.

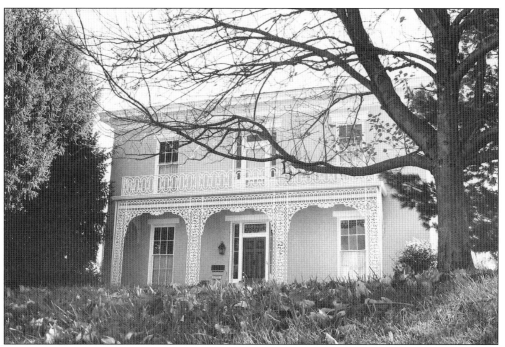

The Samuel Shaw House at 26 Audubon Place was built in 1856. It was constructed in the late Greek Revival style. Samuel Shaw owned 80 acres on Highland Avenue.

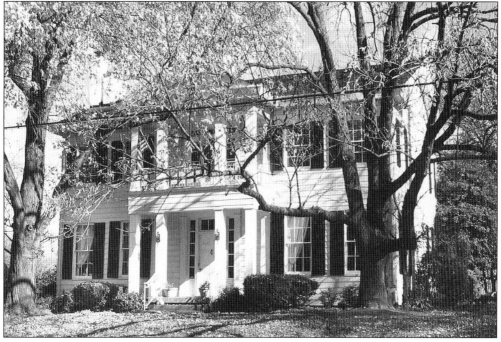

This beautiful home at 1938 North Fort Thomas Avenue was constructed in 1870 and used as a summer home by the original owner. It was constructed in the Greek Revival style. The front porch may have been added after original construction, and the windows in front may have been lengthened to keep up with current styles.

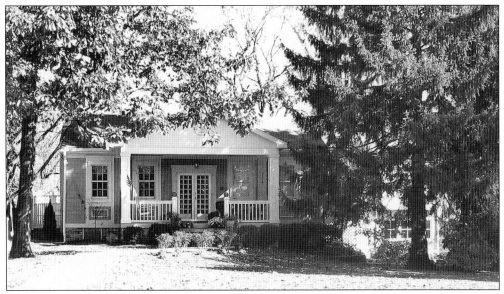

This home, located at 1924 North Fort Thomas Avenue, was built in 1853 and was originally located at the end of Elsmar Drive. It is a basic farmhouse with a center hallway plan. There may have been more than one fireplace when it was built.

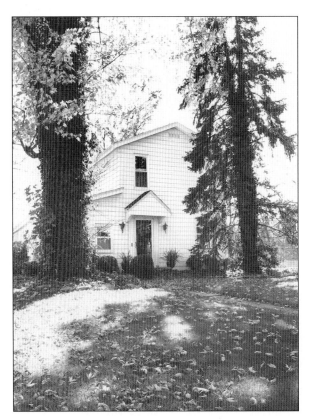

This small farmhouse at 74 Miller Lane was built in 1870 by a farmer named J. M. Miller. It was the only home on a dirt road that continued on to what is now Crow Hill.

This farmhouse was built in 1873 and is located at 19 Pentland Place. It is constructed in the Victorian Vernacular style with the porch added in the late Victorian period. Many people, including the current owner, believe it is haunted by ghosts.

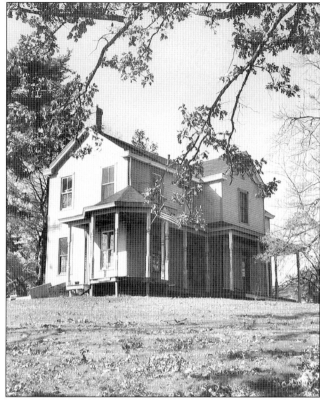

This farmhouse at 446 Highland Avenue was built in 1851. It is a center-passage house because the hallway goes down the center of the first floor.

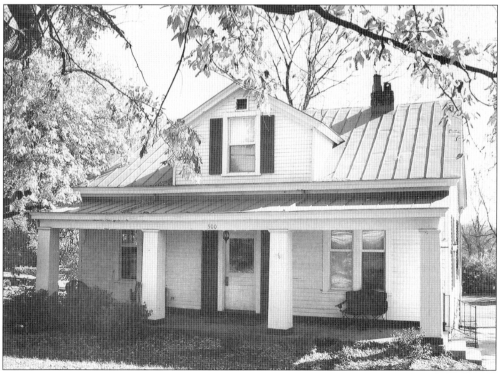

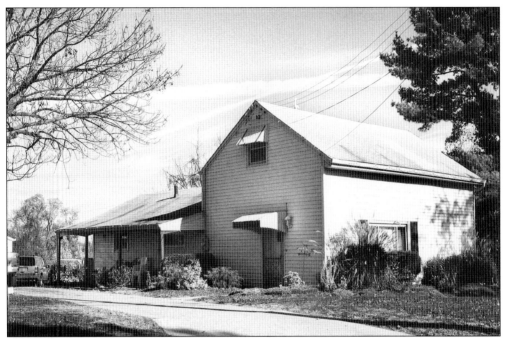

This small farmhouse at 370 Newman Avenue was constructed in 1850. It maintains the original front containing two rooms with a wall in between. The kitchen was located in the back room, and the bedroom would have been upstairs.

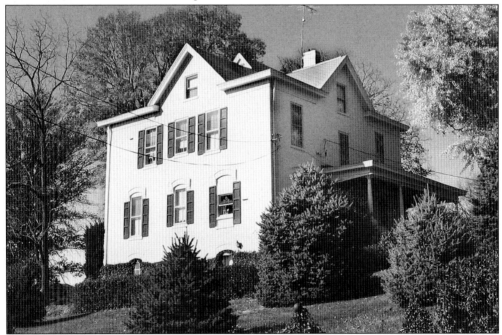

The John Phillips home at 90 South Crescent Avenue was built before 1876 on a large estate that included parts of Grand Avenue, South Fort Thomas Avenue, Military Parkway, and North and South Crescent Avenues. John Phillips was a superintendent at the American Bolt and Nut Works in Newport.

This home at 269 Military Parkway was built in 1876. Military Parkway is one of the oldest streets in Fort Thomas. The top half of the street was constructed by the city of Covington for access to its reservoir. The bottom half connected with Robson Avenue and ended at the Robson home, overlooking Alexandria Pike.

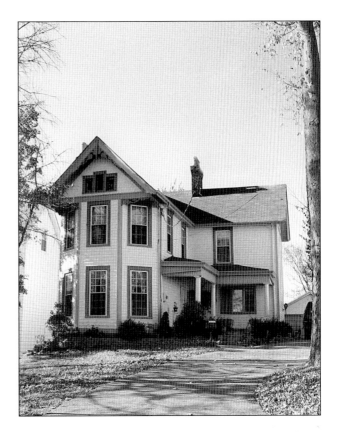

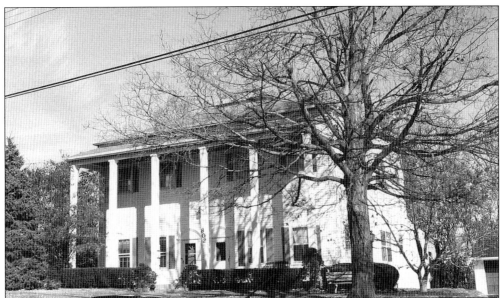

Lockwood Lodge, located at 802 South Fort Thomas Avenue, was built by the Ross family prior to 1883. The large, square two-story home had a second building in the rear for a kitchen and servants' quarters. A cigar store and post office were also located on the south end of the property. Today Rossmore Avenue and Lockwood Place are located on what was once the Ross farm.

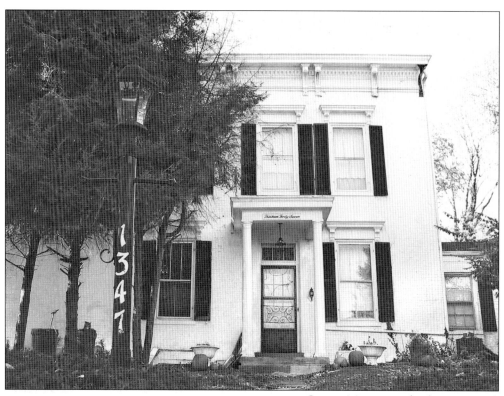

George Morin was the first owner of the classically styled brick home at 1347 South Fort Thomas Avenue. It was built in 1852. J. B. Lock owned the farm in 1896 when the headless body of Pearl Bryan was found of the property. A trial found Scott Jackson and Alonzo Walling guilty of her murder, and they were hung in the yard of the Newport Courthouse in 1897. The Pearl Bryan murder brought national attention to Fort Thomas, known then as the Highlands.

This home was built in 1876 and is located at 275 Military Parkway. It was constructed at the same time as the home next to it at 269 Military Parkway.

The 10-room home of the Gaddis family, located at 20 Gaddis Drive, was built before the Civil War on the Samuel Perry patent, high above Mount Vernon Avenue, which is now Highland Avenue. During the Civil War, officers were billeted in the house, and a cannon stood on the property.

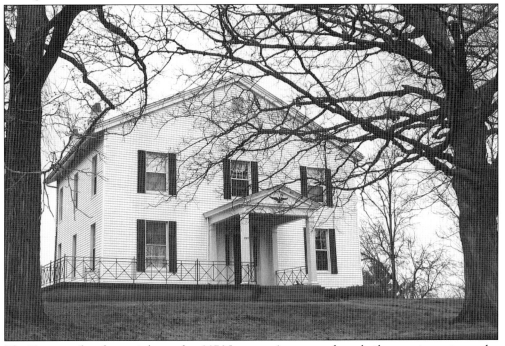

The Newman farmhouse is located at 307 Newman Avenue and was built sometime prior to the Civil War. The large frame home with four chimneys was owned by Mrs. E. Newman in 1883.

43

This home at the end of Military Parkway was built by William Robson in 1851. Robson Spring is located down the hill from the house on Alexandria Pike.

The W. McGrew farmhouse on Newman Avenue was built prior to 1880. Two members of the McGrew family, J. S. and Thomas, were members of the Mount Vernon Home Guard during the Civil War.

Four

NEIGHBORHOODS

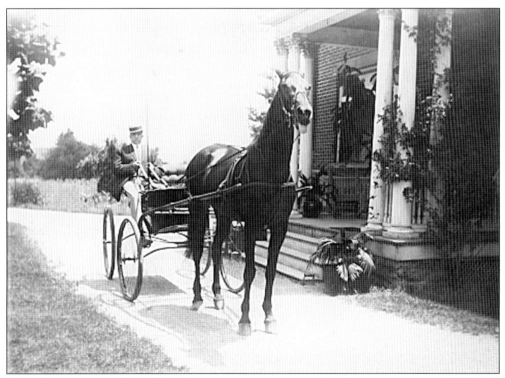

Baron Remme Donnelly and Bess the horse pull up in front of the Donnelly home at 1620 North Fort Thomas Avenue. The Donnelly home was constructed around 1900. The original carriage house is now a single-family home on Earnscliff Avenue. The Donnelly farm was subdivided and once included all of the land between Donnelly Drive and Earnscliff Avenue.

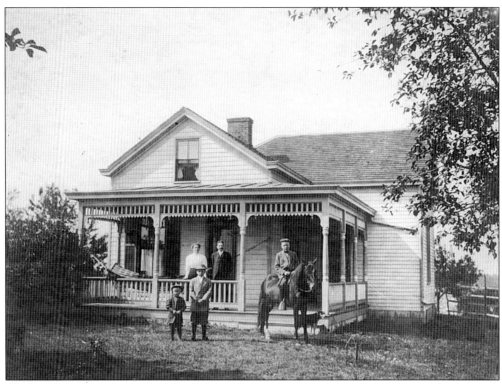

The Landberg farm, located on North Fort Thomas Avenue, was the only home in the far north end of Fort Thomas in 1900. (Courtesy Joyce Steinman.)

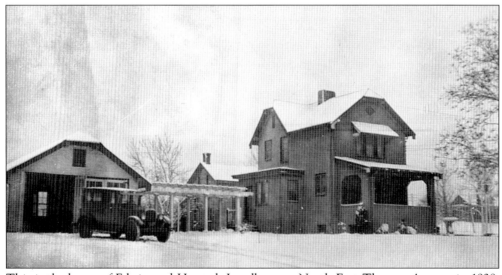

This is the home of Edwin and Hannah Landberg on North Fort Thomas Avenue in 1928. (Courtesy Joyce Steinman.)

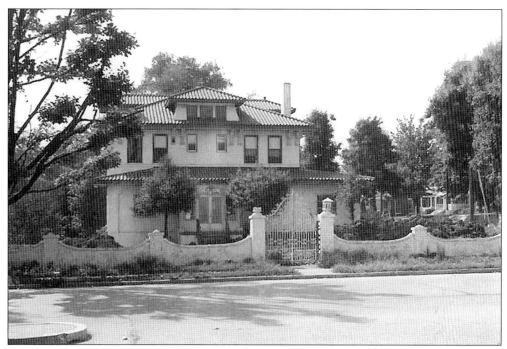

This beautiful home was located at the corner of West Villa Place and South Fort Thomas Avenue. It was used as a nursing home prior to being torn down to make way for construction of an apartment building.

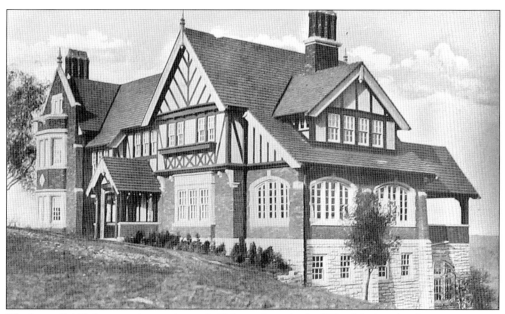

The beautiful Tudor mansion at the end of Manor Lane looked like this shortly after construction was finished.

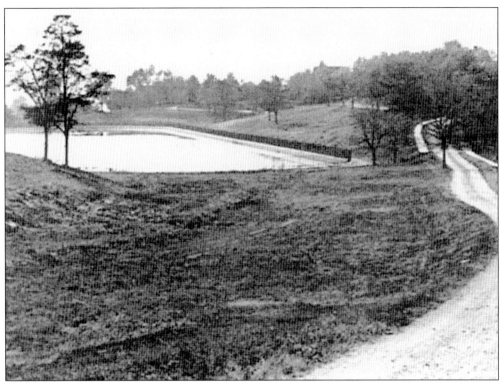

Military Parkway was a one-lane dirt road in 1902. The street was known as Military Park until around 1960.

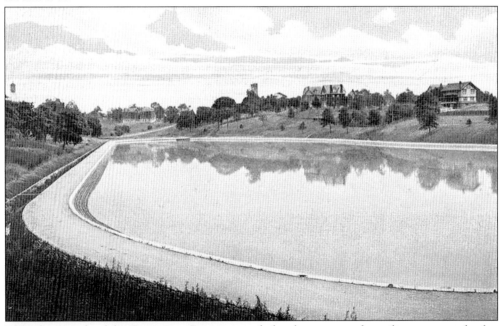

This photograph of the Covington Reservoir includes the tower at the military post and a few of the homes on Tower Place. Military Parkway can be seen as it meanders up the hill to what is now South Fort Thomas Avenue. (Courtesy Ken Fecher.)

Grant Street is one of the oldest roads in Fort Thomas. This photograph was taken after a snow at 45 Grant Street. A horse, covered with a blanket, and a barn can be seen to the right of the 100-year-old house. (Courtesy Jim Nedderman.)

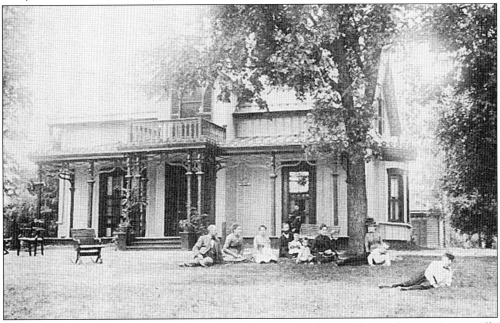

This house and its inhabitants played an important role in early Fort Thomas history. It originally stood where the large white house now stands at 947 South Fort Thomas Avenue. During the Civil War, it was used as a headquarters and hospital. It was owned by Eli Kinney, who sold it in 1870 to Henry Stegeman. The Stegeman family is shown on the front lawn. Frank and Albert Stegeman recline on the grass at right; Harry sits on the porch. The white house now standing there later became the Wadsworth home.

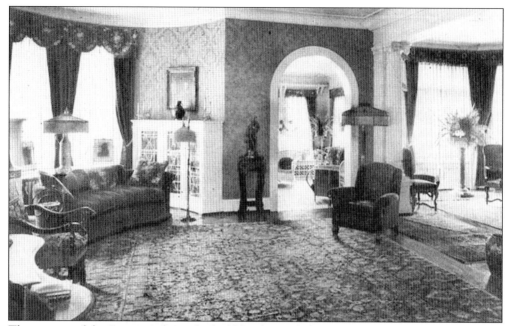

The interior of the Stegeman home looked like this at the turn of the century. The furnishings in the living room and dining room were designed and supplied by the decorating department of the A. B. Closson Jr. Company of Cincinnati. (Courtesy Ken Fecher.)

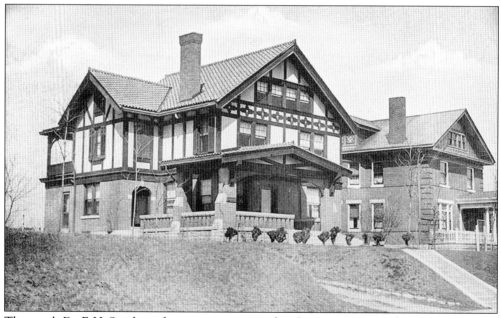

The stately Dr. F. H. Southgate home was constructed on Bivouac Avenue. The Tutor-style home still stands. (Courtesy Ken Fecher.)

 BARRETT PARK

*O*wned for many years by the Barrett family, this beautiful estate, overlooking the Ohio and Little Miami valleys, has been developed into a group of exclusive home sites unsurpassed in Northern Kentucky - - -

*H*ere will be found a truly beautiful development with un-usually fine panoramic views. To the Southeast lies the Ohio River valley and its wooded slopes; then Mt. Washington. Turning East, the Little Miami valley, then Ault Park and Tusculum Heights. To the North, a wooded valley. To the West, from the entrance, can be seen the Union Central Tower, (less than 15 minutes' drive), and the Western hills of Cincinnati beyond - - -

*F*or the particular person who wants to live amid beautiful surroundings, with views of woods, valleys and rivers, who wants to be sure that homes of similar calibre to his own will be around him, Barrett Park offers unusual advantages - - -

*E*very care has been taken to make Barrett Park the really beautiful residential community that its splendid natural setting deserves. Two winding roads have been laid; good trees have been planted and parks and entrance landscaped by a well-known firm. Two thousand cubic yards of rich topsoil have been laid on these sites to produce good lawns - - -

*C*areful consideration has been given to the protection of of this property through adequate restrictions, and amongst those decided on are the following:

Each home to be planned by a recognized architect, and to cost not less than $15,000.

Only single family residences to be erected, and no detached garages.

A few of these sites have approximately 90 feet of road frontage; the others have 100 feet or more - - -

*W*ater, gas, telephone and sewer services are already laid. Electric service and street lighting (boulevard lights,) will be installed before the first home is built - - -

*B*arrett Park is within the city limits of Fort Thomas. The entrance is from the North end of Fort Thomas Avenue, exactly opposite Covert Run Pike - - -

*W*e are very enthusiastic about this property, and our aim is to have it known as one of the choicest developments near Cin-cinnati. Residents of Fort Thomas will, we hope, be glad that such a development has been added to our city - - -

*T*his property is now for sale, and even though you may not be a prospective purchaser, we should be very pleased if you would pay Barrett Park a visit - - -

J. M. ROBINSON, Agent - -
Hiland 2030

CLAUDE W. JOHNSON,
LESLIE GARDNER,
Fort Thomas, Kentucky.

This 1930 description of the development plan for Barrett Drive and Walden Lane was part of a brochure for prospective buyers. (Courtesy Bert Thomas.)

This brochure advertises lots for sale in Barrett Park in 1930. Barrett Park would become Barrett Drive and Walden Lane. The land was purchased and developed by Leslie Gardner and Claude W. Johnson Sr. Leslie Gardner built the beautiful stone house at the end of Barrett Drive. (Courtesy Bert Thomas.)

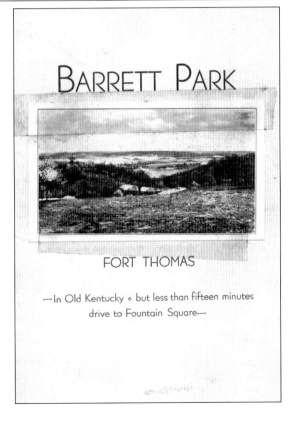

BARRETT PARK

FORT THOMAS

—In Old Kentucky ❖ but less than fifteen minutes drive to Fountain Square—

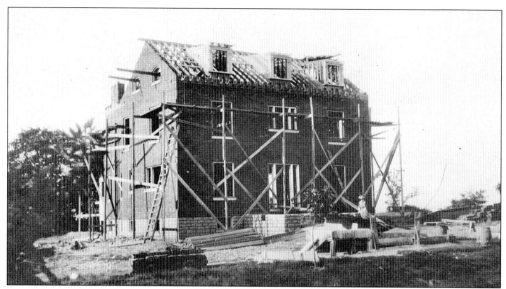

The Johnson family home is under construction at 33 Oak Ridge. It was one of the first homes constructed on the street and has a beautiful view of the Ohio River. (Courtesy Bert Thomas.)

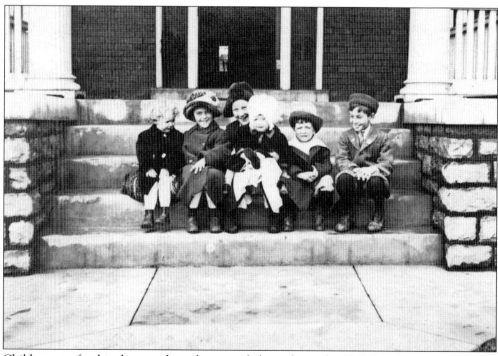

Children pose for this photograph on the steps of a home located at 33 Oak Ridge in 1915. Stewart Weber, the boy on the right, became an architect and designed the home of Louise (Pat) Johnson at 28 Barrett Drive. Louise (Pat) Johnson is seated on a lap in the center of the photograph. (Courtesy Bert Thomas.)

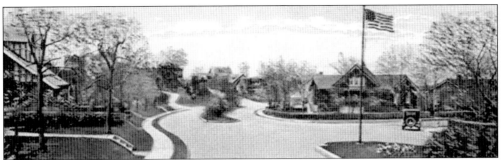

Here is an excellent view of Riverside Parkway along with Sunset Avenue and Rob Roy Avenue. The first home in the Briarcliffe subdivision was constructed in 1899 by Jacob Schneider. It stands at 35 Sunset Avenue. (Courtesy Ken Fecher.)

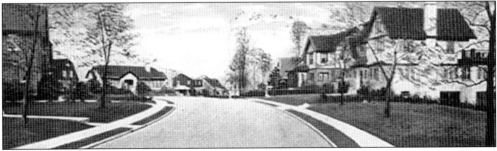

This is another early view of Riverside Parkway in the Briarcliffe subdivision. Note the size of the trees in front of the homes. Today many of these trees are nearly 100 years old. (Courtesy Ken Fecher.)

The first homes built on Miami Parkway were at the top of the hill. Miami Parkway is a part of the Briarcliffe subdivision that was developed by Chris and Ed Weber of Fort Thomas. The Weber brothers also designed the Governor's Mansion in Frankfort. (Courtesy Ken Fecher.)

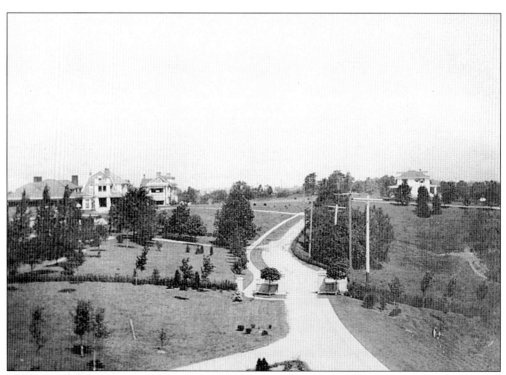

This is an interesting view of Shaw Lane looking north toward Miller Lane. Today these yards are full of mature trees.

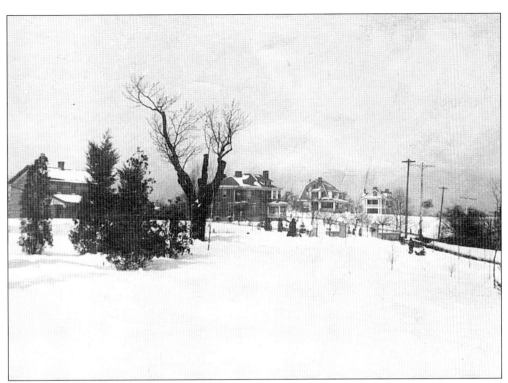

The stately homes on Shaw Lane stand out in this winter scene from the 1920s. Samuel Shaw constructed the first home on Shaw Lane during the Civil War. His home was at the end of the street.

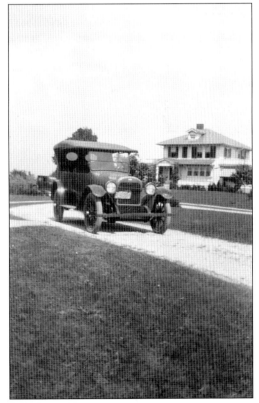

The beautiful Benton home on Shaw Lane can be seen in the background of this photograph taken in the early 20th century. Many of the old homes on Shaw Lane have beautiful views of the Ohio River.

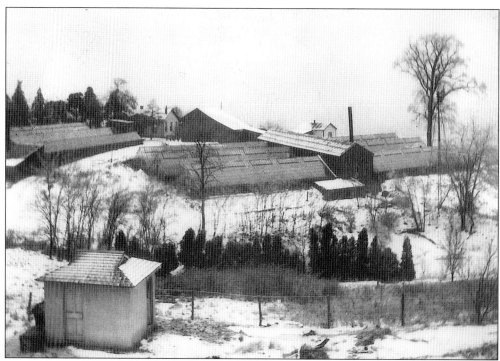

This photograph of what is now Crow Hill was taken from the back of 32 Shaw Lane in 1905. The 1900–1901 city directory lists the owner as Frank Huntsman, a florist, and the address as the east end of Evans Avenue. By the late 1920s, the greenhouses were gone. All that remained was the white house to the left in the photograph, a pond, and a beautiful field of daffodils (Courtesy Margaret Ross.)

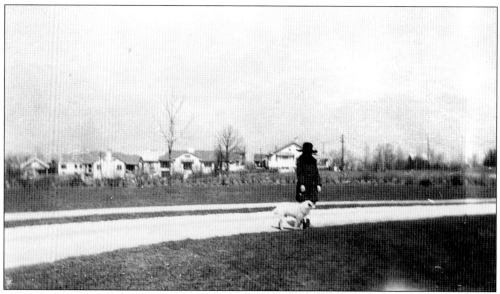

A woman walks her dog in 1915. The new homes in the background are on Miller Lane. In the 19th century, Miller Lane was a dirt road leading to the farm of J. M. Miller.

Five

CHURCHES

In 1852, Methodists
and Baptists built a
30-by-40-foot wooden
church with a steeple
and bell tower. The
church was built
on land owned by
William Taliaferro
near the corner of
present-day North
Fort Thomas Avenue
and Bellaire Place.
When Highland
Methodist Church
was constructed
in 1900, the little
wooden church was
converted into a
house and moved
down the street to
1314 North Fort
Thomas Avenue.

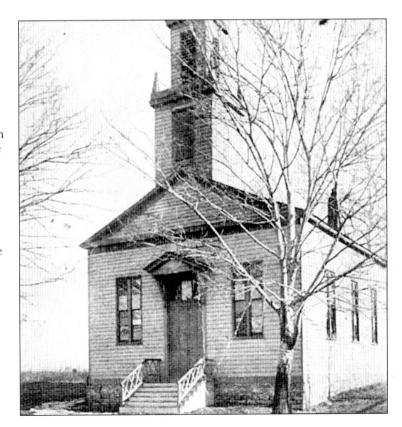

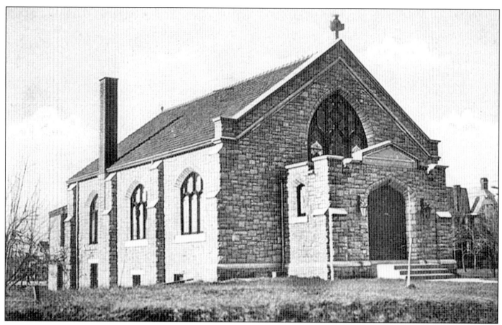

St. Andrews Episcopal Church opened its doors in 1909. The property for the church was purchased in 1907 by Harry Wadsworth, Charles Helm, and Frank Bigstaff.

St. Andrews Episcopal Church is the second oldest existing church building in Fort Thomas, with its cornerstone dated 1909. The first Episcopal services took place in the small chapel at the military post in 1895. In 1905, the Episcopalians moved to the meeting room at Central School. The current church lot on South Fort Thomas Avenue cost $2,000. The Reverend Arthur Marshall served as the first minister at St. Andrews. (Courtesy Pete Garrett.)

Members of the congregation pose for a photograph together in front of St. Andrews Episcopal Church in 1909. (Courtesy Pete Garrett.)

United Church of Christ was founded as Christ Evangelical Church in 1906. The present church building at 15 South Fort Thomas Avenue was completed in 1928. The land on which the church was built was part of the 80-acre Samuel Shaw estate. His house, built in 1859, is now a professional office building behind the church.

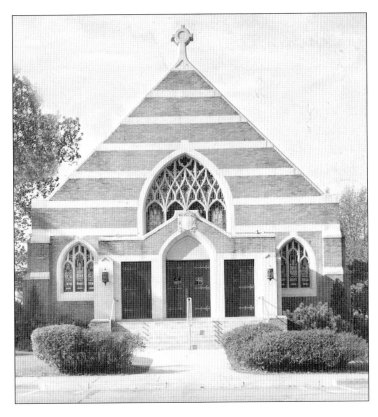

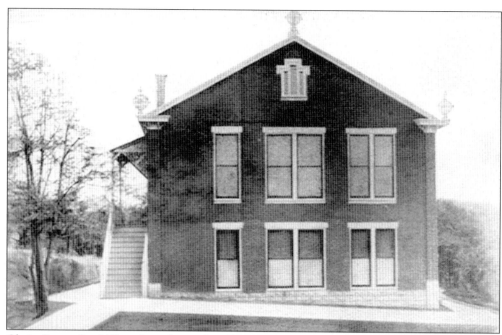

Christ Evangelical Chapel was located on Forest Avenue and was the home of United Church of Christ from 1910 until 1928. It was located directly behind the Pendery Insurance Building on North Fort Thomas Avenue. The chapel was sold in 1928 and eventually torn down. (Courtesy Ken Fecher.)

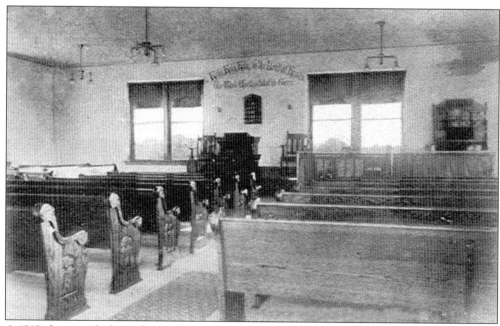

A 1910 photograph shows the interior of Christ Evangelical Chapel on Forest Avenue. (Courtesy Ken Fecher.)

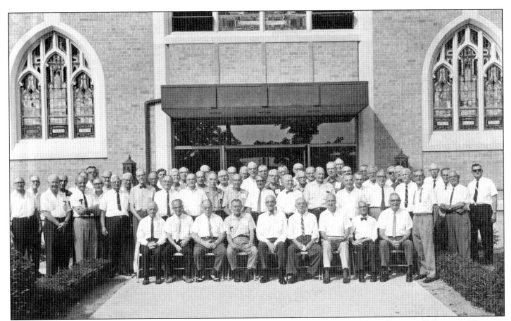

Members of the Fort Thomas Retired Men's Club are pictured in 1965 in front of United Church of Christ. The Retired Men's Club met at the church until the club disbanded in early 2006. (Courtesy Campbell County Historic Society.)

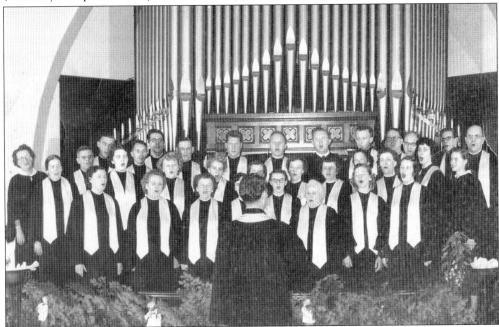

The choir at Highland United Methodist Church performs during a service over 50 years ago. Highland United Methodist Church is the oldest church building in Fort Thomas. It was built in 1900 by Henry Schriver, the same builder who constructed the buildings at Fort Thomas military post. The church held its first services at Mount Pleasant, the Taliaferro family home built in 1830. After William Taliaferro built Mount Pleasant School in 1832, church services were held in that log cabin.

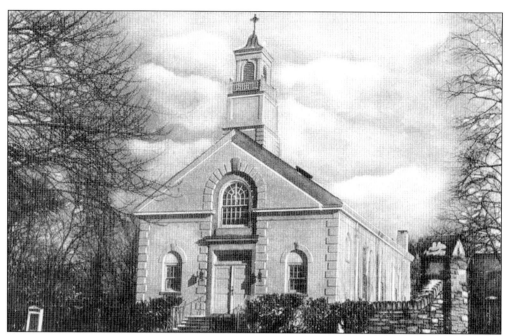

This is an early photograph of First Presbyterian Church, built in 1923 at the corner of South Fort Thomas Avenue and Avenel Place. The land was once owned by the Jesuit Fathers of St. Xavier in Cincinnati. (Courtesy Ken Fecher.)

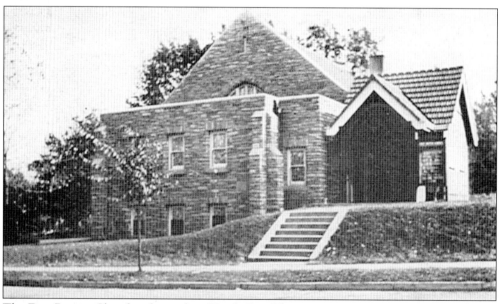

The First Baptist Church is located on North Fort Thomas Avenue. First Baptist Church was formed in 1915, and the congregation met at first in the frame building next to the City Building and then in the City Building. The church was built in 1922. (Courtesy Ken Fecher.)

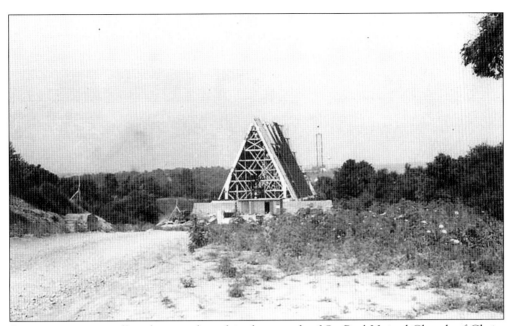

Construction was well underway when this photograph of St. Paul United Church of Christ was taken in 1957. The church is located on the connector road between Grand Avenue and Newman Avenue.

Charles Tharp (left) and Rev. Leon B. Gilbert are in front of Highland Hills Baptist Church shortly after completion of this addition in 1963. (Courtesy Campbell County Historical Society.)

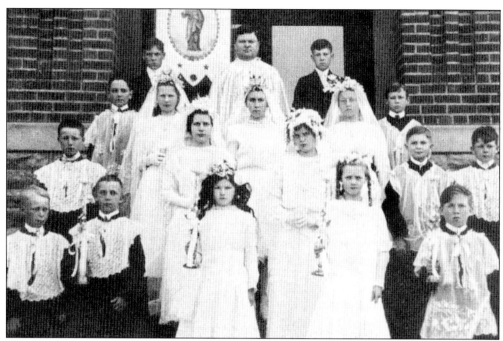

The first Holy Communion in 1914 took place at St. Thomas Church on Grand Avenue. The cornerstone for the church was laid in 1902. The building was razed in 2005 to make way for condominiums. (Courtesy St. Thomas Church.)

The beautiful cross at the top of St. Thomas Church can be seen in this 60-year-old photograph. Construction of St. Thomas Church began in 1937, and the cornerstone was laid by Bishop Francis W. Howard on March 6, 1938. The exterior is made of Indiana Bedford limestone, and beautiful Saint Meinrad sandstone was selected for the interior.

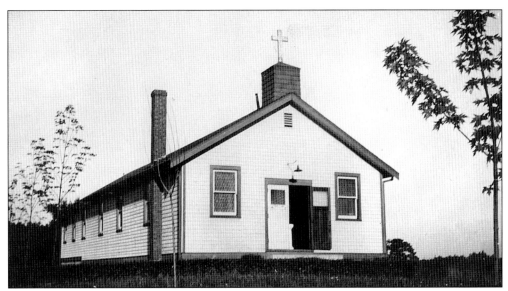

The original St. Catherine Church was built in 1931. The Sears-Roebuck model church building cost $3,600 to erect. A new church replaced the wooden church in 1963. (Courtesy Ray Duff.)

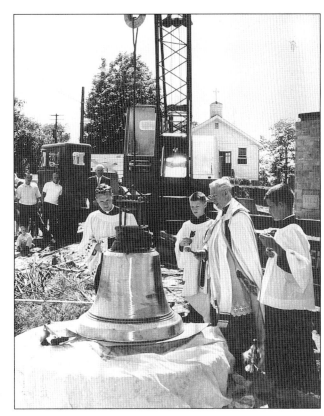

The blessing of the bell took place with Msgr. John McCrystal at St. Catherine Church in 1962. The old church on Rossford Avenue can be seen in the background. (Courtesy Campbell County Historical Society.)

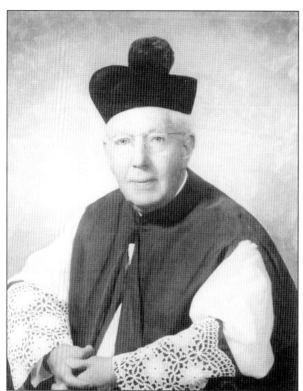

Msgr. John McCrystal spent many years at St. Catherine Church. He was the first priest at the parish and served from 1930 until 1969. (Courtesy Ray Duff.)

This photograph was taken in 1929 from South Fort Thomas Avenue at its intersection with Alexandria Pike. The original First Christian Church building can be seen on Alexandria Pike. (Courtesy Dick Thompson.)

Six

THE MILITARY POST

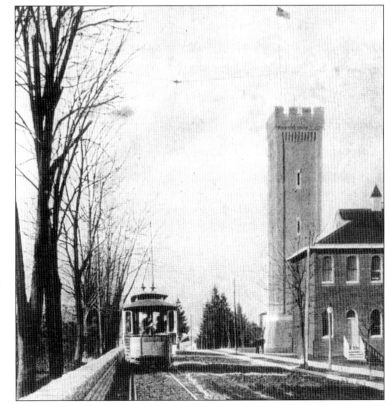

This view of the stone water tower on South Fort Thomas Avenue includes a streetcar and streetcar tracks when South Fort Thomas Avenue was a dirt road. The building on the right was part of the military post and was torn down years ago. The rock wall is also gone.

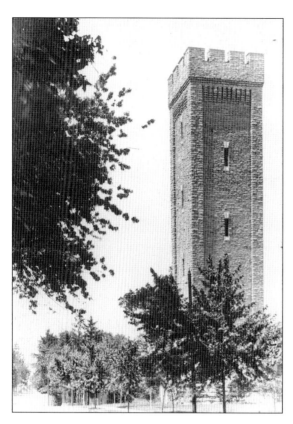

This photograph of the stone water tower at the military post was taken in 1920. The military post used an average of 15,500 gallons of water a day, and the huge steel tank inside the tower never ran out of water. The number 16 on the steel door tells us that the tower was the 16th building constructed at the military post.

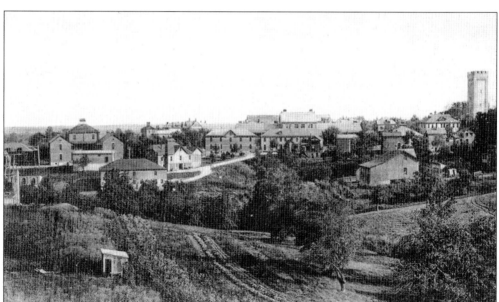

This panoramic view is from the water tower on South Fort Thomas Avenue and shows the stone water tower, military post, and the L. L. Ross farm (802 South Fort Thomas Avenue). Lockwood Place and Rossmore Avenue were developed on land that was once part of the L. L. Ross farm. (Courtesy Ken Fecher.)

Troops recuperated from injuries at Fort Thomas after returning home from the Battle of Santiago in Cuba in 1898. Many soldiers from Fort Thomas lost their lives in the Spanish-American War.

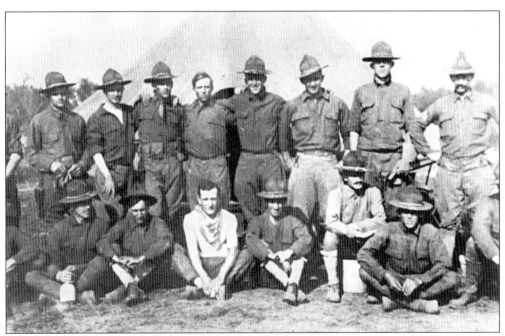

In May of 1898 the entire 6th Infantry left Fort Thomas to fight the Spanish in Cuba. The U.S. battleship *Maine* had exploded in Havana Harbor with a loss of 266 lives, and President McKinley declared war on Spain in April 1898. (Courtesy of Ken Fecher.)

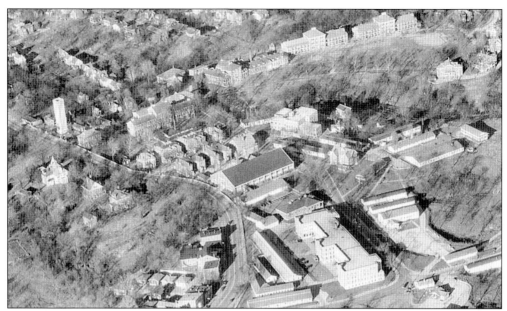

This aerial photograph of Fort Thomas includes the Armory (center) and the Mess Hall (one story building, top center). Barracks were located where the tennis courts are situated today. (Courtesy Dick Thompson.)

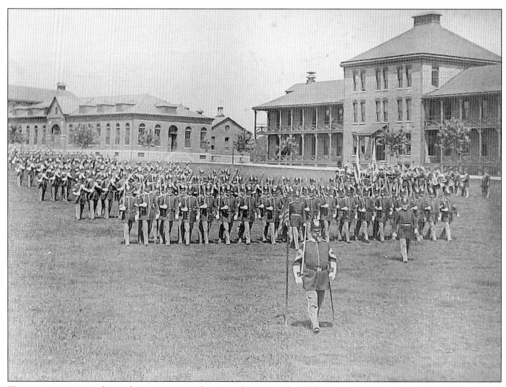

Troops are in marching formation on the parade grounds of the military post. The Mess Hall, now the Fort Thomas Community Center, can be seen in the top left corner of this photograph

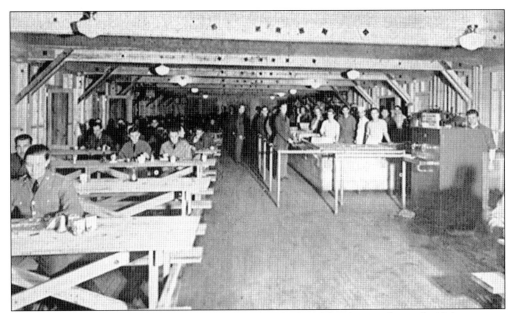

The interior of the Mess Hall at the military post looked like this in the early 20th century. The Mess Hall also contained a jail. The Mess Hall was constructed in 1890 and is listed on the National Register of History Places. (Courtesy Ken Fecher.)

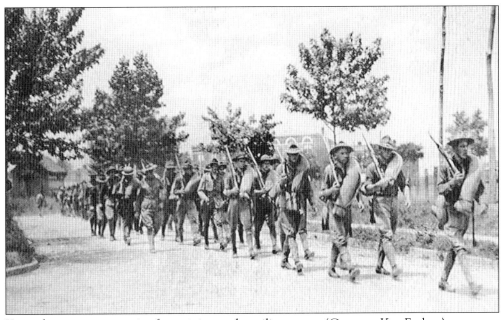

Kentucky state troops arrive for training at the military post. (Courtesy Ken Fecher.)

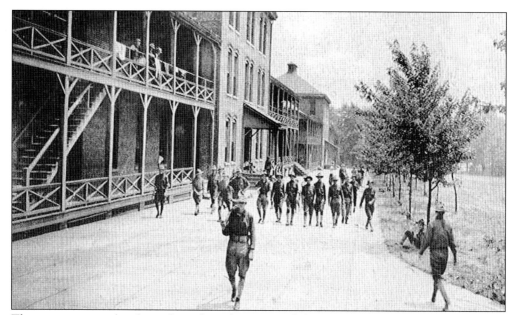

These troops are at their barracks at the military post while training for war with Mexico in 1916. A huge crowd gathered on the soccer field and Highlands High School's first football field across the road from the Midway Business District (now the location of the Veterans Administration Hospital) for a parade down River Road to the train station to see the troops off. Their mission was to capture or kill Pancho Villa, a Mexican revolutionary who had killed 16 U.S. citizens in New Mexico. (Courtesy Ken Fecher.)

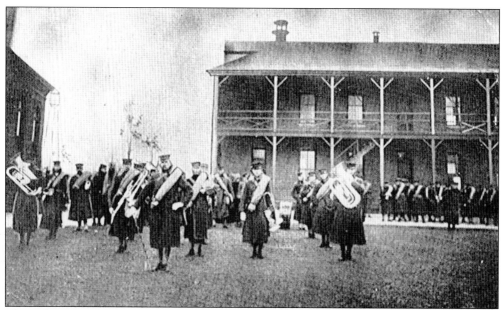

The military band lines up to perform as the 6th Infantry prepares to leave for the Philippines in 1899 after its successful campaign in Cuba. (Courtesy Ken Fecher.)

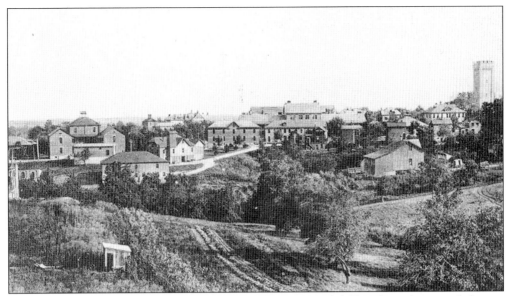

This photograph was taken from the L. L. Ross farm. Gen. Phil Sheridan, who visited the site with a few soldiers from the Newport Barracks, chose the fort's location in 1887. Most of the tract of land was cleared for farming, and almost all of it was blanketed by a peach orchard. When General Sheridan was taken to Lee Battery Lookout (where officer homes are located today), he viewed the Ohio River and proclaimed that the new military post would be the "West Point of the West." (Courtesy Ken Fecher.)

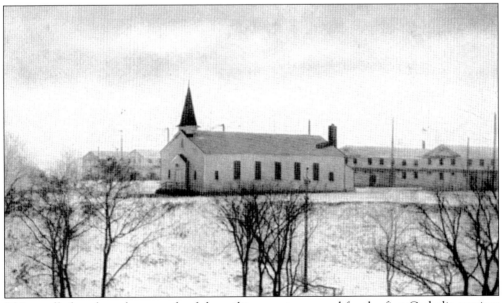

This small chapel on the grounds of the military post was used for the first Catholic services in Fort Thomas. It was also used for Episcopalian services on Sunday afternoons. Col. Melville Cochran, the first commandant of Fort Thomas, lived on the grounds of the military post and was an Episcopalian. (Courtesy Ken Fecher.)

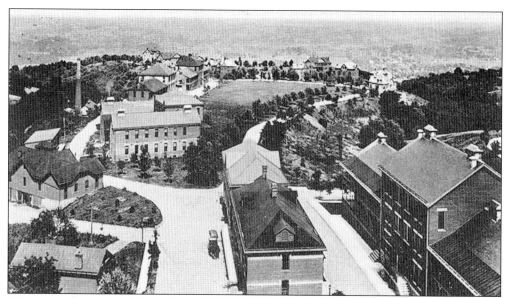

Here is another view of the military post from the stone water tower on South Fort Thomas Avenue. The parade grounds can be seen in the center of the photograph. Troops would conduct war games down the hill (center, right) where the amphitheater is now located.

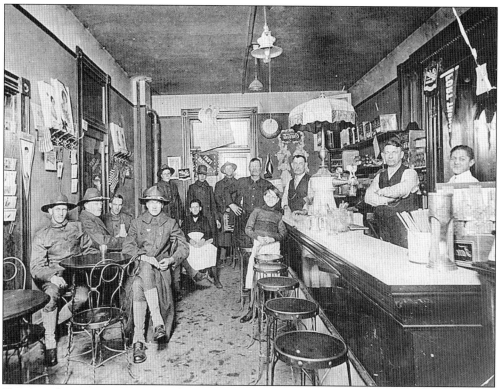

Troops gather at an ice-cream parlor in the Midway Business District around 1900. (Courtesy Ray Duff.)

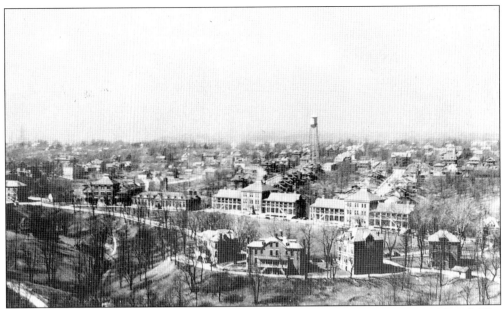

This photograph was taken from the Kinney Mansion (now Carmel Manor Nursing Home). The water tower was at the corner of South Fort Thomas Avenue and Rossmore. It was torn down years ago. The barracks to the right of the mess hall were eventually torn down and are now part of the softball field and parking lot in Tower Park. (Courtesy Dick Thompson.)

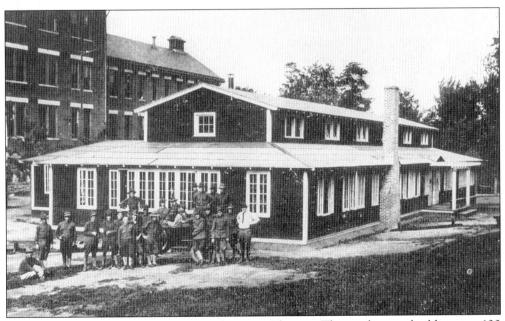

In 1917, the YMCA hut was constructed in Fort Thomas. The single-story building was 100 feet long and 60 feet wide with a dirt path leading to the sidewalk on what is now Cochran Street. The YMCA sign came down after World War I, and the building was used as the social and entertainment center for officers and their wives and families. The building was used as the headquarters for the Red Cross during World War II. This photograph was taken in 1918. (Courtesy Kenton County Public Library.)

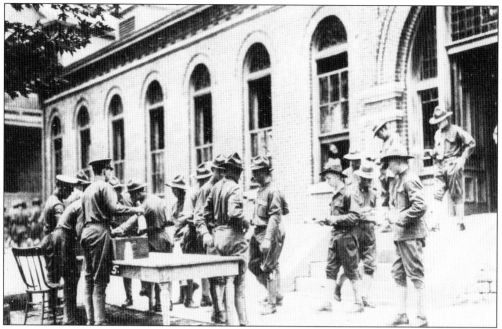

Troops gather near the entrance of the Mess Hall in 1920. The Mess Hall as constructed with bricks from derrick's Highlands Brick Yard. The brick yard is now the site of Highlands High School. (Courtesy Kenton County Public Library.)

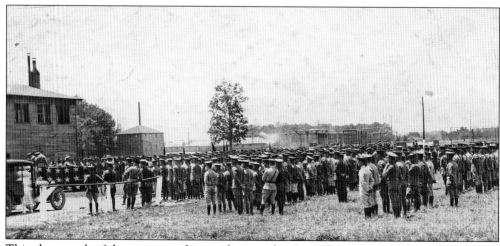

This photograph of the troops on the parade ground at Fort Thomas was taken in 1921.

Troops are in formation on the parade grounds of Fort Thomas in the 1890s. The stone water tower can be seen in the distance, and the Mess Hall (now the Fort Thomas Community Center) is just beyond the military band. The parade ground is now used as a community softball field in Tower Park.

South Fort Thomas Avenue and the stone water tower looked like this in 1929. The streetcar tracks can be seen running down the center of the street.

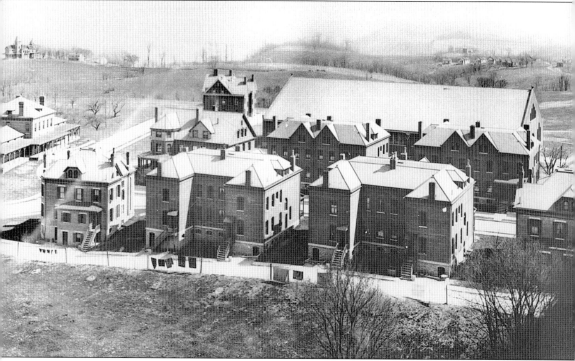

This photograph taken from the top of the stone water tower provides an excellent view of the officers' quarters on Greene Street and the Armory. The Kinney Mansion (now Carmel Manor Nursing Home) can be seen on the hill in the distance on the top left of the photograph.

Seven

THE BUSINESS COMMUNITY

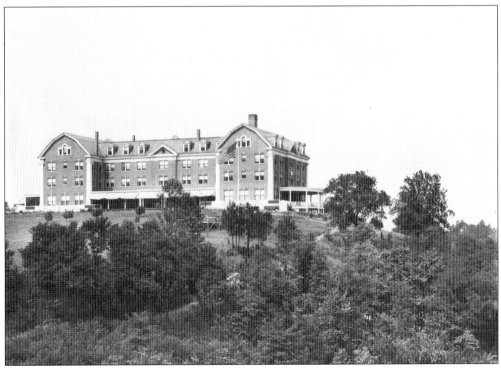

The Altamont Hotel was built in 1905 and was located off Bivouac Avenue, where the home at 20 Crown Point is located today. The Shelly Arms Hotel was built on the south side of the road leading to the Altamont. Traces of the paved road from the Altamont to the Ohio River are still evident in the woods. Old sidewalks used by guests can also be found on the wooded hillsides overlooking the river.

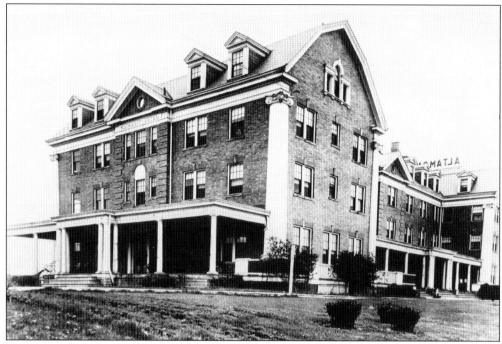

This is another view of the Altamont Hotel located on a bluff overlooking the Ohio River. In 1912, new owners of the hotel changed its name to the Altamont Springs Hotel to promote a false claim that mineral springs were discovered on the property. The Altamont was used as an army hospital throughout World War I. The Altamont and Shelly Arms were demolished in 1920.

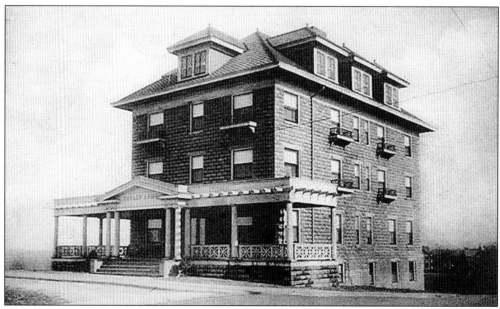

The Shelly Arms Hotel operated next to the Altamont Hotel and was built in 1907. It was used as quarters for doctors and nurses when the Altamont Hotel was converted into an army hospital during World War I. (Courtesy Ken Fecher.)

Alice Schriver Ware and her daughter, Jessie Lee, pose for the camera in the front yard of the Ware home at the corner of Villa Place and South Fort Thomas Avenue in 1907. The Avenel Hotel can be seen in the background. Henry Schriver, owner of the construction company that built the buildings at the military post, built the Avenel Hotel in 1894. There were 30 to 40 guest rooms on the upper floors. The hotel was torn down in 1928.

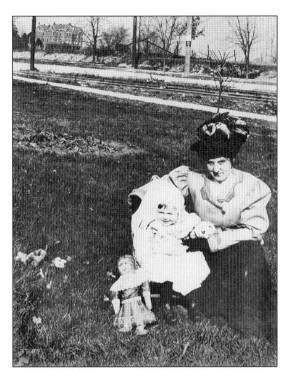

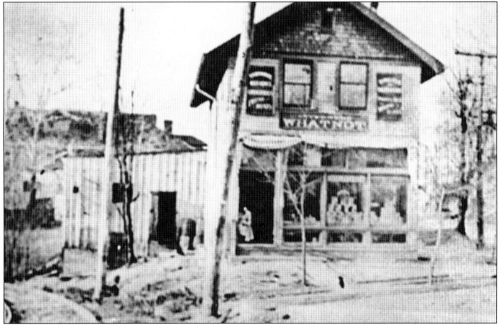

This early photograph of Inverness shows the streetcar tracks to Newport and the Whatnot General Store. The Whatnot opened in the 1890s and was owned by Alfred T. Morris. Al Nagel bought the store in 1910. It was eventually converted into a gas station. In the early 20th century, the Whatnot General Store was broken into on several occasions. Alfred Morris set a trap at the front door with a loaded shotgun. The next time the intruder entered the store, he set the trap off and was killed.

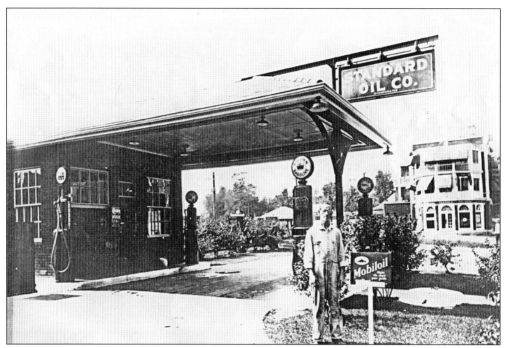

This is how the Standard Oil Company station at Inverness looked in 1925. The site is now a city park. (Courtesy Dick Thompson.)

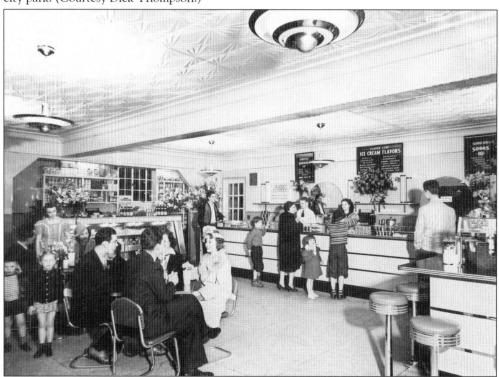

Cloverleaf Dairy on Highland Avenue (now a dance studio) was a popular eating establishment in Fort Thomas. This photograph was taken in 1937. (Courtesy Dick Thompson.)

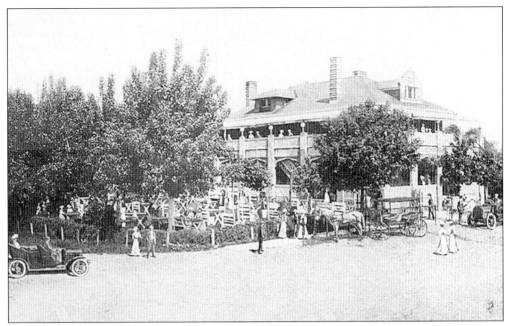

Detrich's Club House was a popular gathering place for good food in the Highlands in the early 20th century. Detrich's was located on the corner of South Fort Thomas Avenue and Grandview Avenue. (Courtesy Ken Fecher.)

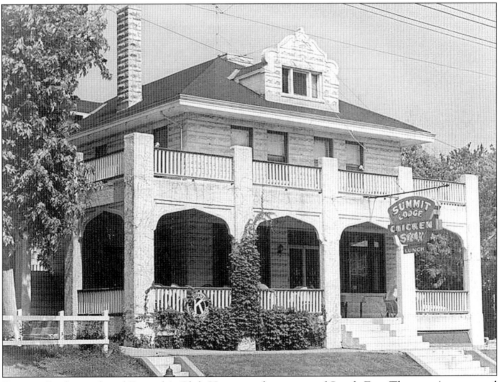

Summit Lodge replaced Detrich's Club House at the corner of South Fort Thomas Avenue and Grandview. It was known for its outstanding chicken dinners. (Courtesy Ken Fecher.)

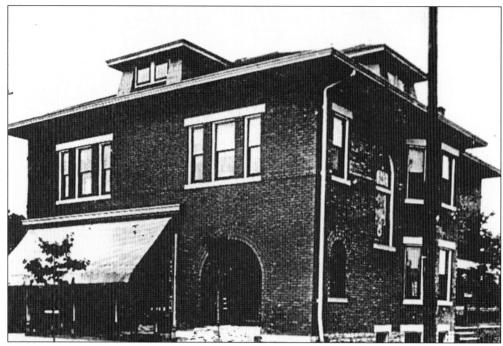

Stegner Grocery opened in 1905 on the corner of North Fort Thomas Avenue and Miller Lane. It remained in business for over 60 years. The building was also used as a restaurant before being torn down and replaced by the building that houses the Fort Thomas Board of Education.

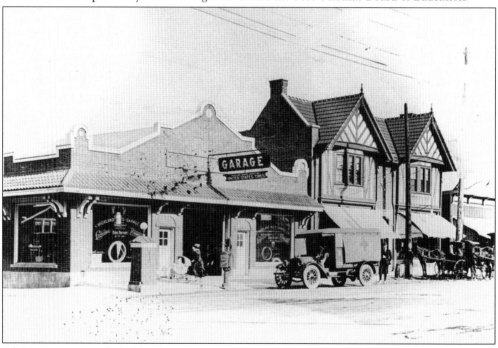

Al Stegeman owned Highland Auto Garage from 1915 to about 1935. His sons built the Fort Thomas Roller Rink in the same location and operated that business through the 1940s. (Courtesy Dick Thompson.)

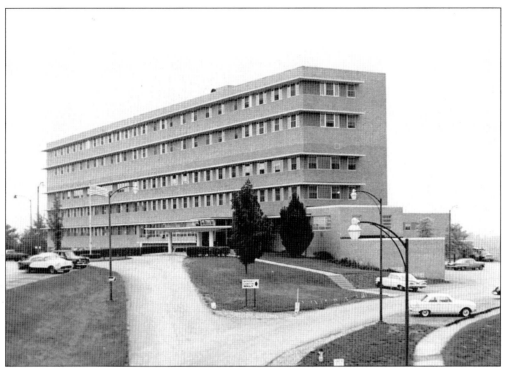

The original St. Luke Hospital looked like this in 1960. Major expansion and affiliation with the Health Alliance have helped St. Luke provide state-of-the-art medical care to residents of Northern Kentucky. (Courtesy Campbell County Historic Society.)

The old roller rink/Kroger building was torn down to make way for the Towne Center development on North Fort Thomas Avenue between Miller Lane and Lumley Avenue.

Hiland Cab Company opened in 1929 on the corner of South Fort Thomas Avenue and River Road under the ownership of Arthur Wehmeyer Sr. The business continued into the 1960s. (Courtesy Dick Thompson.)

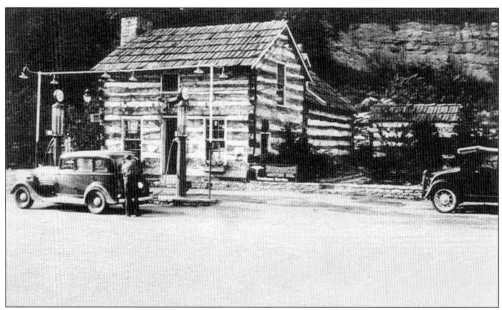

The Log Cabin Service Station was located on Alexandria Pike where Moore's Home Improvement Center is located today. The owner was Floyd Prickett. Prickett sold gas and specialized in "lubrication, tires, and battery service." (Courtesy Dick Thompson.)

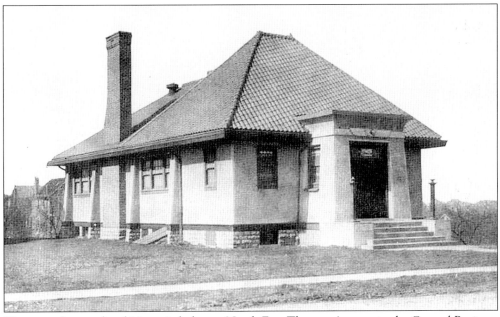

The recently completed Masonic lodge on North Fort Thomas Avenue in the Central Business District looked like this in 1910. The first meeting of a group of Master Masons took place at the Central School Building (the location of the City Building today) for the purpose of organizing a lodge of Master Masons in Fort Thomas. Albert Vinton Stegeman was elected master of the group. (Courtesy Ken Fecher.)

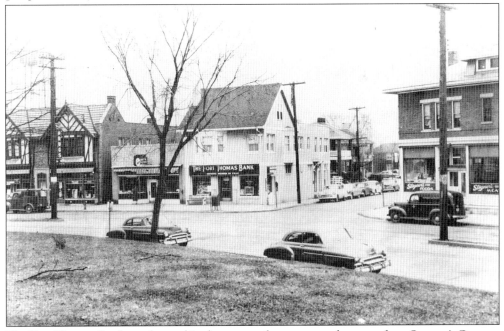

The Fort Thomas Bank was located in the center of town across the street from Stegner's Grocery Store. This photograph was taken in the 1950s. The Fort Thomas Bank would become the Fort Thomas–Bellevue Bank a few years later. Today Citizen's Bank of Northern Kentucky is located where Fort Thomas Bank stood.

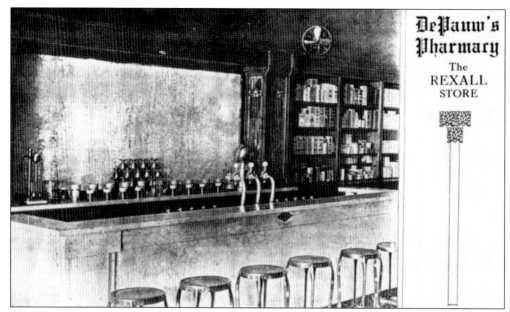

DePauw's Pharmacy was a Rexall Store that promoted itself as having a "Sanitary Soda Fountain." DePauw's was located in the Midway Business District. This photograph was taken in 1919. (Courtesy Dick Thompson.)

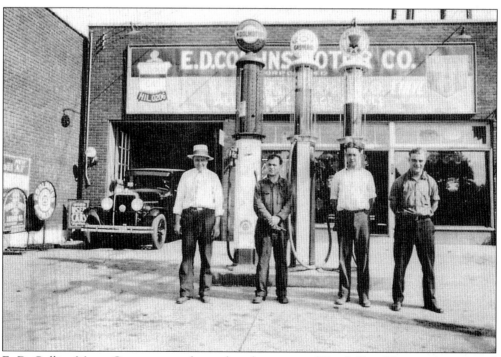

E. D. Collins Motor Company was located at the corner of South Fort Thomas Avenue and Bivouac Avenue. This 1927 photograph includes owner E. D. Collins on the left with Gab (second from left) and Jack Murphy (second from right). The man on the right is unidentified. (Courtesy Dick Thompson.)

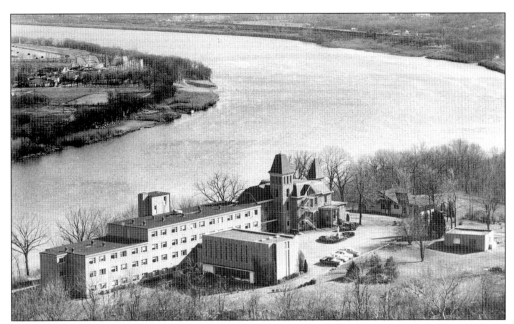

Here is an aerial view of Carmel Manor Nursing Home in the 1950s. The original rock house (with two towers) was built by Eli Kinney in the 1870s and is located on the spot where Daniel Boone made his camp when he visited this area of the state. Kinney was the first treasurer of the District of Highlands in 1867. Rumor has it that gold from a payroll for troops assigned at the Newport Barracks was buried here during a Native American attack. The gold has never been found.

The first barbershop in Fort Thomas was located in the Midway Business District. It was listed in a directory of businesses in the Midway along with 11 saloons/restaurants, a shoemaker, florist, dairy, bakery, grocery, hotel, gold melter, and blacksmith. There were no businesses in Fort Thomas prior to construction of the military post in 1887. (Courtesy Dick Thompson.)

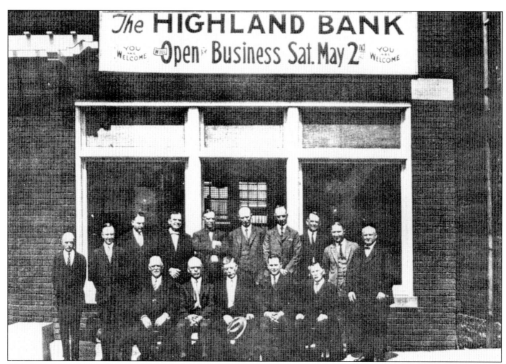

The Highland Bank opened for business in the Midway Business District in 1925. The bank was bought by Newport National Bank in 1960 and moved to the corner of North Fort Thomas Avenue and Highland Avenue (now occupied by Wardens Realty). (Courtesy Dick Thompson.)

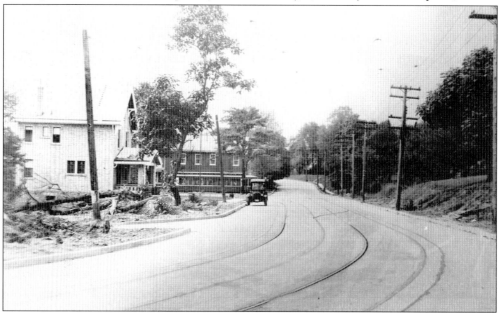

This early photograph of South Fort Thomas Avenue is of particular interest because it shows where the streetcars turned around for their return trip through Fort Thomas and on to Newport. A streetcar can be seen just to the left of the parked car. The building directly behind the streetcar is now occupied by the Blue Marble Children's Bookstore. (Courtesy Dick Thompson.)

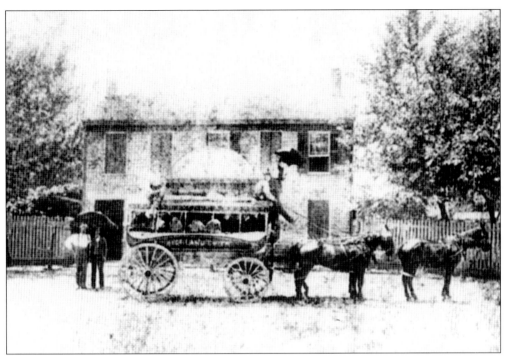

The first Fort Thomas bus operated between the Highlands and Newport. This photograph was taken in front of the Heidelberg Inn (the current location of St. Therese Church) in 1880. (Courtesy Dick Thompson.)

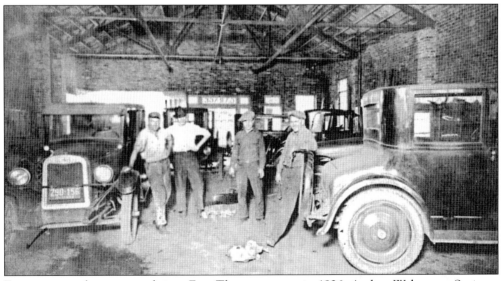

Four men are shown at work in a Fort Thomas garage in 1926. Arthur Wehmeyer Sr. is on the far right. Wehmeyer opened the Hiland Cab Company on River Road in 1929. (Courtesy Dick Thompson.)

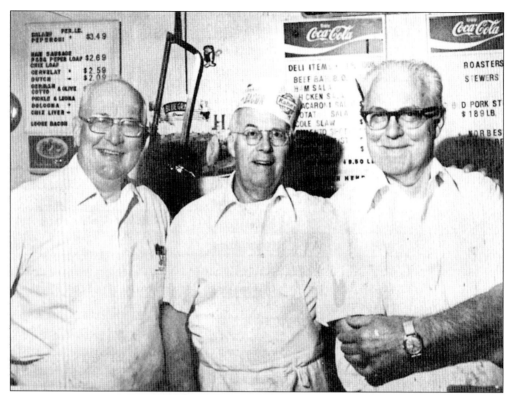

The Enslen brothers, Glenn (left), Rudy (center), and Howard, opened Enslen's Fine Food at 917 North Fort Thomas Avenue in 1940. Quality meat, custom cut, was their forte. Their grandfather owned a slaughterhouse on Licking Pike, and their father and uncles operated a meat and grocery business at Eighth and Roberts Streets in Newport.

For many years, Schulker's Drug Store occupied the building that now houses Fort Thomas Drugs. Schulker's had a popular soda fountain and was next to the Hiland Theater building. The hats on display were on sale for the Fort Thomas Centennial Celebration in 1967. (Courtesy Campbell County Historic Society.)

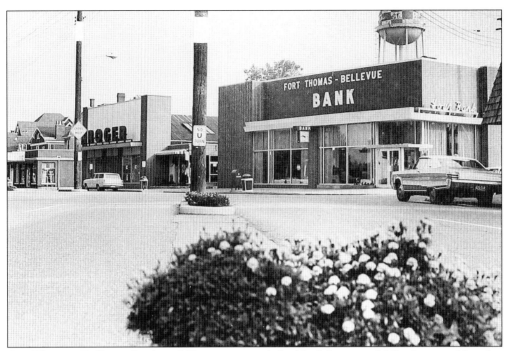

Fort Thomas–Bellevue Bank and Kroger occupied the block between Miller Lane and Lumley Avenue in the 1960s. Wiedemann Bakery can be seen to the left of Kroger. (Courtesy Campbell County Historic Society.)

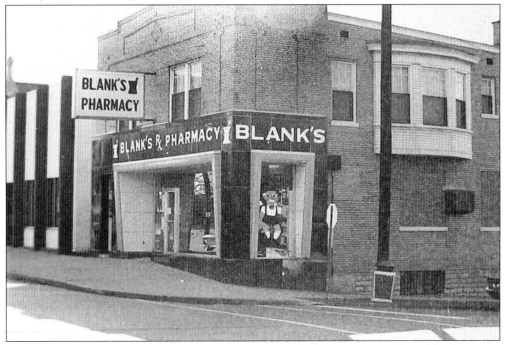

Blank's Pharmacy occupied the corner of South Fort Thomas Avenue and Highland Avenue for many years. The building was previously occupied by Highland Bank. (Courtesy Campbell County Historic Society.)

Inverness Country Club opened with a spectacular social event on July 21, 1900. More than 500 guests enjoyed music by Michael Brand. Inverness Country Club included a nine-hole golf course and tennis courts. It was the second golf course to open in Greater Cincinnati and was bordered by North Fort Thomas Avenue, Memorial Parkway (a streetcar line at the time), Water Works Road, and West Southgate Avenue. (Courtesy Ken Fecher.)

Highland Country Club opened in 1915, two years after the clubhouse at Inverness Country Club was destroyed by fire.

Eight

AROUND TOWN

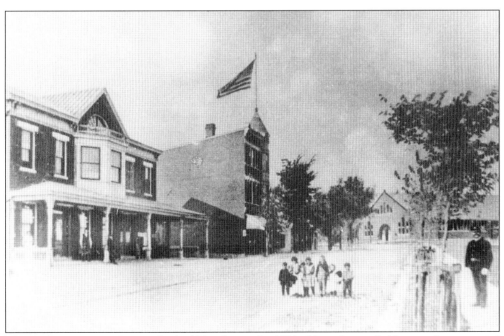

The Midway Business District looked like this in the 1890s. Note the six children in the street and the Armory building up the street. The Armory was used for recreation and training by the troops at the military post. It still stands and is an important recreational facility in Tower Park.

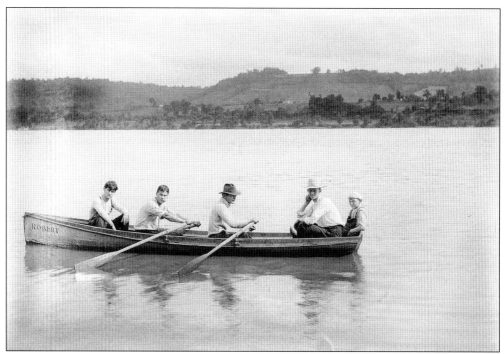

Fort Thomas residents enjoy a ride on the Ohio River in their boat named *Robert* in 1908. Note how two men could row the boat at the same time. (Courtesy Peter Garrett.)

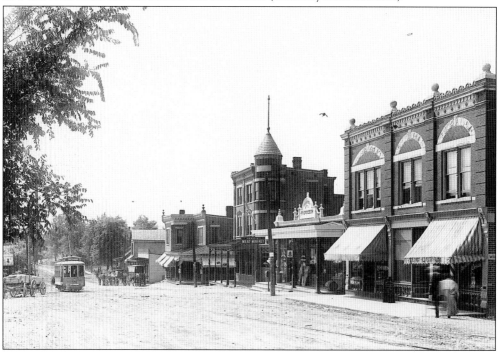

This photograph of the Midway Business District in the 1890s includes the Fort Thomas streetcar and a number of horses and wagons. The buildings remain much the same today as when they were built for businesses serving the troops stationed at the military post.

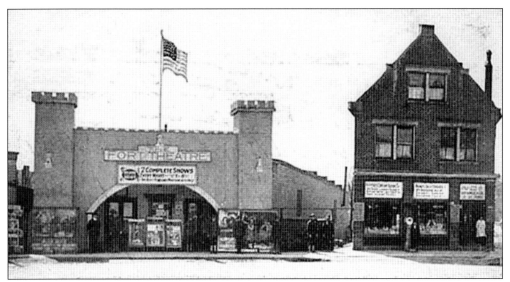

The Fort Theatre was a popular recreation destination for troops stationed at the military post in the early 20th century. Hiland Cab Company later occupied the building. (Courtesy Dick Thompson.)

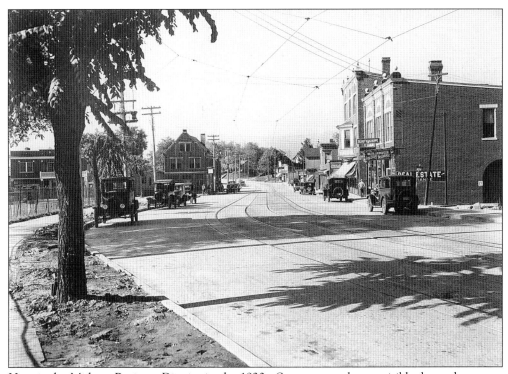

Here is the Midway Business District in the 1920s. Streetcar tracks are visible down the center of South Fort Thomas Avenue. Note the wooden-plank sidewalks.

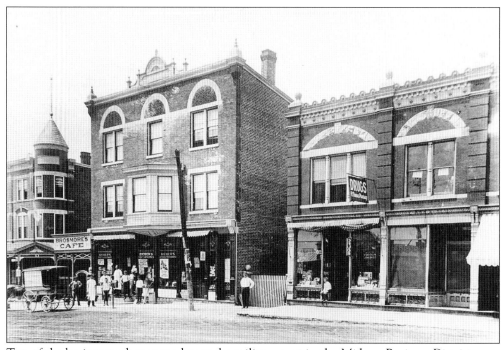

Two of the businesses that opened near the military post in the Midway Business District were Brosmore's Café (now the Olde Fort Pub) and Fort Thomas Pharmacy. The streetcar tracks are visible in the middle of the dirt road.

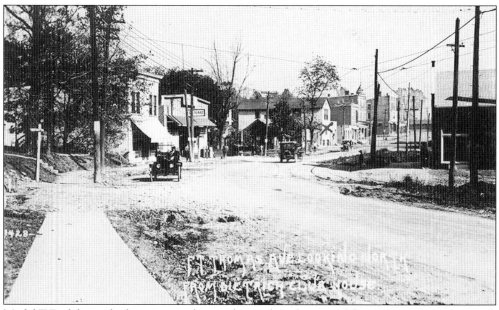

Model T Ford drivers had to negotiate bumpy dirt roads at the turn of the century. This photograph is of South Fort Thomas Avenue looking north toward the Midway Business District. (Courtesy Ken Fecher.)

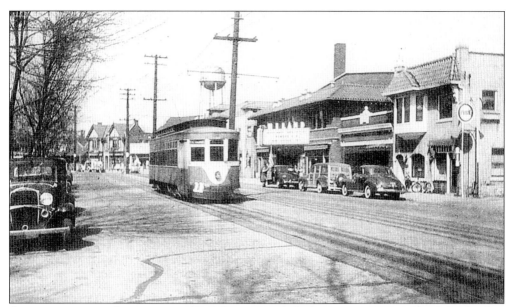

Streetcars continued to operate in Fort Thomas until the last run on August 24, 1947. The first electric streetcars arrived in Fort Thomas in 1891, and the fare to Newport was 5¢. Streetcars that operated in the 1890s in Newport, Bellevue, and Dayton were pulled by two-mule teams, but electricity was needed to climb the hill to Fort Thomas. (Courtesy Dick Thompson.)

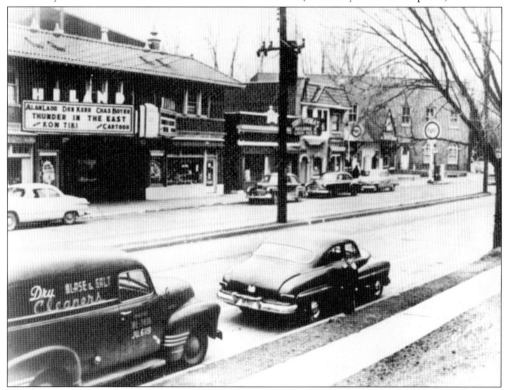

This photograph shows the Hiland Movie Theater, Fort Thomas Building and Loan Association, and a Pure Oil gas station in the 1950s.

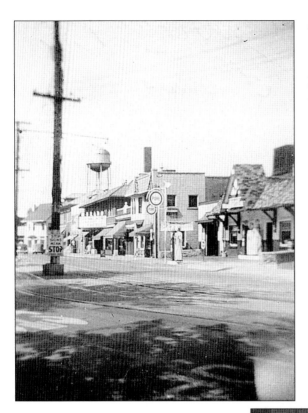

This view of the Central Business District in the 1940s reveals how little the center of town has changed over the years. Of course, the Hiland Theater and a Pure Oil gas station have been replaced by a professional office building and fast-food restaurant.

Vera Hughes and Jack Utz are seen at the Fort Thomas Roller Rink in 1940. The roller rink was located in the center of town where the Towne Center is located today. The roller rink eventually closed, and a Kroger grocery store took its place. (Courtesy Dick Thompson.)

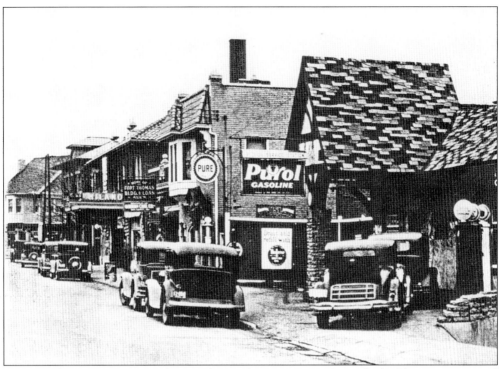

This is Basham Garage on North Fort Thomas Avenue in 1934. Later the building was converted into a bar and restaurant known as the Busy B. (Courtesy Dick Thompson.)

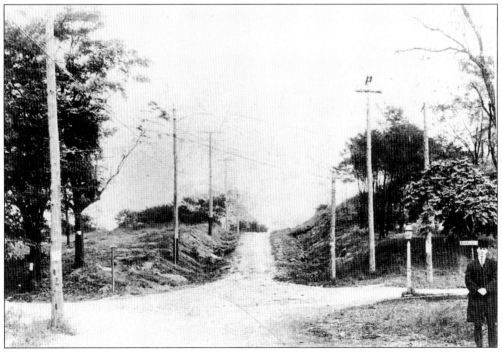

This photograph, taken in 1900, shows a man at the intersection of North Fort Thomas Avenue and Sterling Avenue. Rob Roy Avenue is the one-lane dirt road going up the hill.

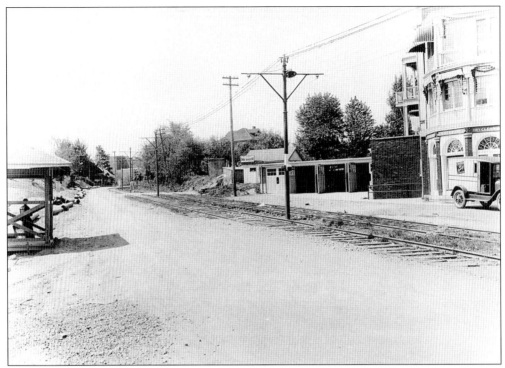

Memorial Parkway at Inverness was not much more than a streetcar line in 1928. One can see Highlands High School in the distance. A simple streetcar shelter is on the left side of the photograph.

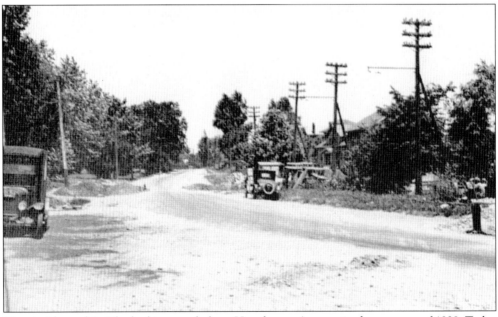

Here is Alexandria Pike looking south from Hawthorne Avenue in the summer of 1929. Today this stretch contains many homes and businesses. (Courtesy Dick Thompson.)

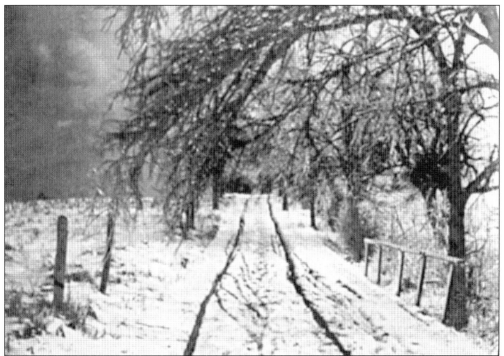

John Spencer Littleford took this photograph on March 20, 1906, looking south on Shaw Lane near his family estate. On it he inscribed the following: "A fine rain began falling the evening of the 18th and continued all of that night and all day on the 19th. It froze on everything as fast as it fell, growing to such weight as to break branches off the trees. On the 19th, which was the writer's 50th birthday, Harry Furneaux, Bert, Roger, John, George Littleford and myself stayed home and took a tramp all over the Littleford Point [now Crow Hill], down through the valleys, etc."

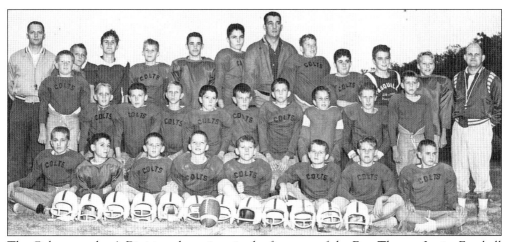

The Colts were the A Division champions in the first year of the Fort Thomas Junior Football League in 1959. The team was coached by Bert Bathiany (standing, left), Jack Kuhnhein (standing, center), and Jerry Wright (standing, right). (Courtesy Mick Foellger.)

This 1961 view of Grand Avenue looks up the hill to the south from the current location of Grand Towers in Newport. (Courtesy Ed and Bev Harber.)

A horse and buggy cross over the creek on Covert Run Pike in 1890. Covert Run Pike was a main access road to Newport.

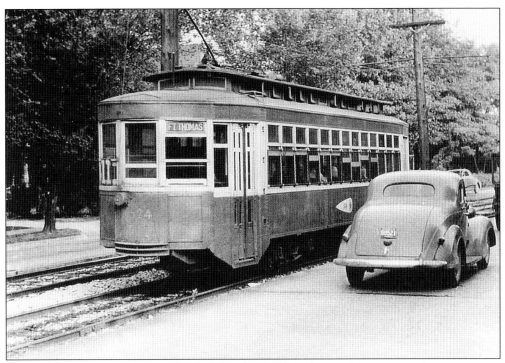

The Fort Thomas streetcar makes a stop in the middle of town. Streetcars took passengers to Newport, Cincinnati, Covington, and Fort Mitchell.

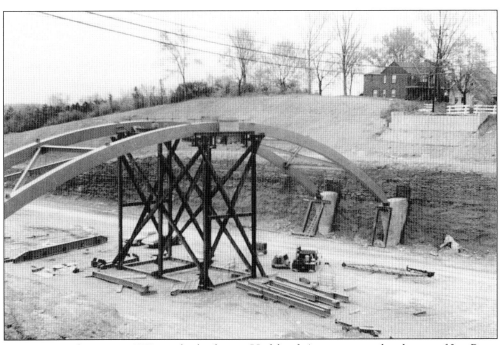

Construction begins in 1979 on the bridge on Highland Avenue named in honor of Joe Ross. The bridge crosses over I-471. Joe Ross was an outstanding athlete at Highlands High School who died in the Vietnam War.

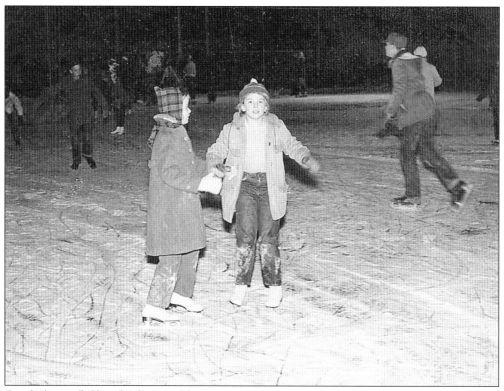

Carol Blevins (left) and Sally Donaldson enjoy ice-skating on the frozen tennis courts in Highland Park around 1960.

Grand Avenue was a much narrower street in 1954. This photograph from the top of the hill looks toward the entrance to St. Luke Hospital. (Courtesy Ed and Bev Harber.)

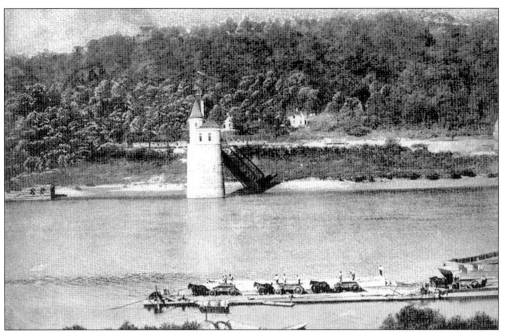

This photograph is taken from the Ohio side of the Ohio River and shows the reservoir pumping station in Fort Thomas. Notice the horse-drawn wagons on the dock on the Ohio side of the river. (Courtesy Ken Fecher.)

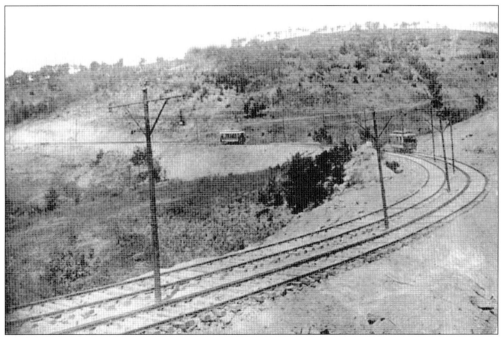

At one time, Memorial Parkway was the route used by the streetcar line between Newport and Fort Thomas. This photograph, taken in 1910, shows two streetcars rounding Horse Shoe Bend. (Courtesy Ken Fecher.)

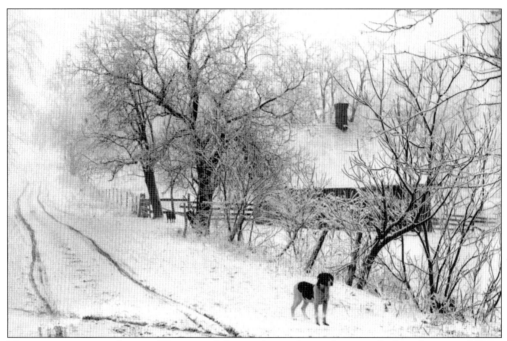

This winter scene with a small home and dog in the road was photographed in the area of Shaw Lane in 1906. (Courtesy Pete Garrett.)

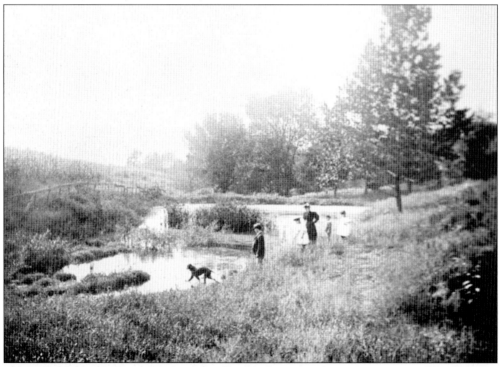

This pond occupied the current site of Orchard Hill Road and Meadow Lane in 1890. The area was full of open fields until development began in the 1950s. The site of Rossfort Park used to be a farm with many horses.

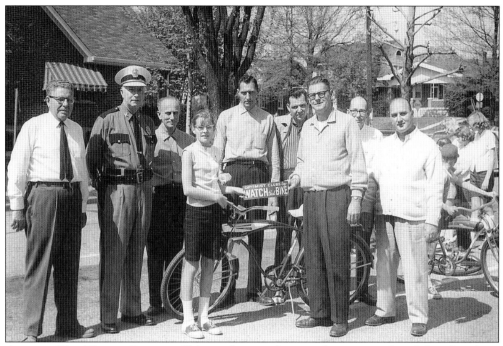

A group of Fort Thomas Optimist Club members are shown with a young girl at a bike safety clinic on South Fort Thomas Avenue in the 1950s. The girl is holding a sticker that reads, "Optimist Clubs say Watch that Bike." (Courtesy Ray Duff.)

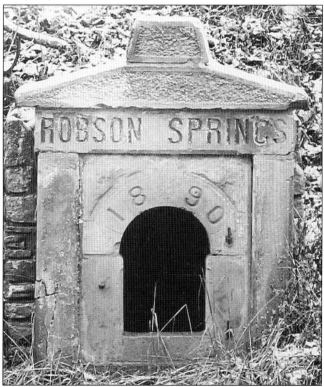

Robson Spring was a source of fresh spring water for many years for Fort Thomas residents living on the south side of town. The spring is located on Alexandria Pike just below the old Robson home on Military Parkway. Travelers used to stop at Robson Spring to give their horses a drink as they traveled between Newport and Fort Thomas and Alexandria. Robson Spring is dry today, but the rock monument built in 1890 to mark its location remains in good condition. (Courtesy Campbell County Historic Society.)

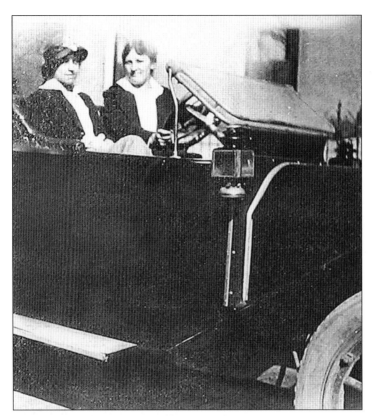

The top is down as two women cruise the streets of Fort Thomas in 1917. Enjoying the beautiful weather were Norma Long Kurgynski (left) and Edna Schweikert Wasser. (Courtesy Campbell County Historic Society.)

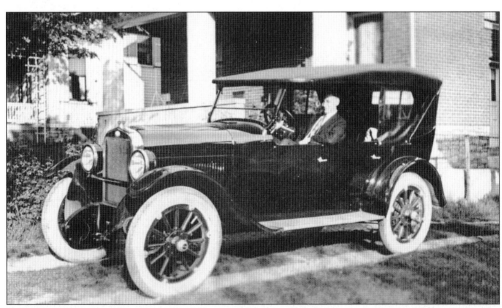

Bill Thompson, proud owner of a new car, is shown in his driveway at 624 South Fort Thomas Avenue in 1922. Thompson was the warehouse and trucking manager at Procter and Gamble. (Courtesy Dick Thompson.)

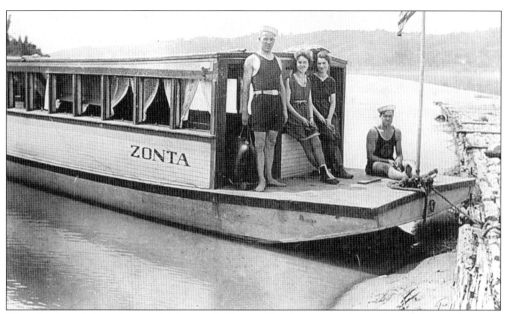

Ed and Hannah Landberg and Mary and Charlie Sparka, pictured here from left to right, relax on the Sparka's houseboat named *Zonta*. The boat is docked on the Fort Thomas shore of the Ohio River in the early 20th century. (Courtesy Joyce Steinman.)

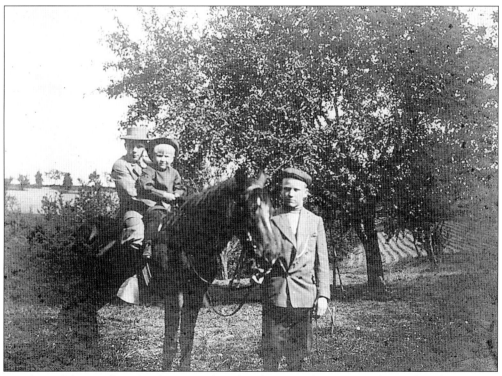

Members of the Landberg family enjoy riding their horse on their farm in the north end of town in the early 20th century. Note the cultivated fields in the background.(Courtesy Joyce Steinman.)

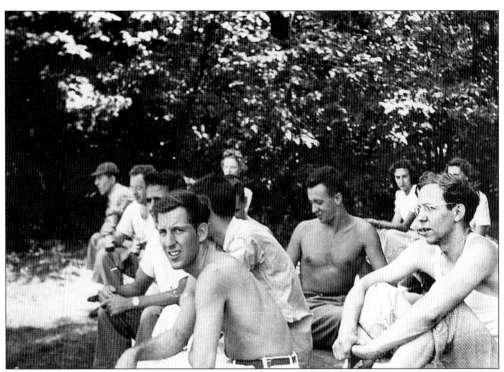

World War II veterans wait to take the field in a softball game at Highland Park. The two shirtless players are Bud Pogue (looking at the camera) and Bill Thomas (looking down).

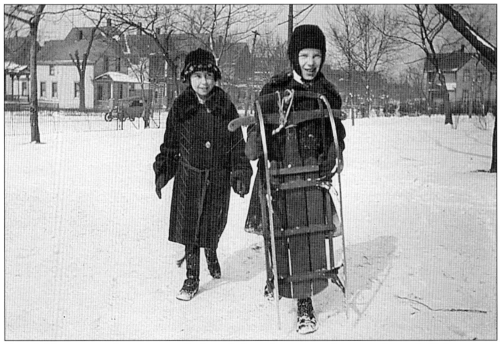

Two children are on their way to ride their sleds in the center of town in the early 20th century. The hills of Fort Thomas are perfect for sledding.

Highlands High School students are caught fooling around on the railroad tracks near the Ohio River in 1935. The tracks follow the Ohio River and Route 8 for five miles through Fort Thomas.

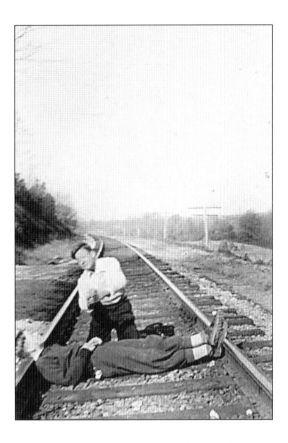

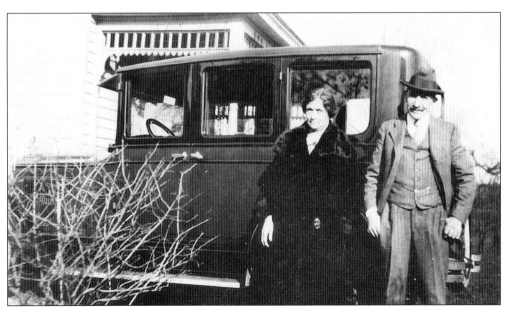

Clara and Charles Landberg pose beside their new automobile. Their home on North Fort Thomas Avenue can be seen in the background of this photograph. (Courtesy Joyce Steinman.)

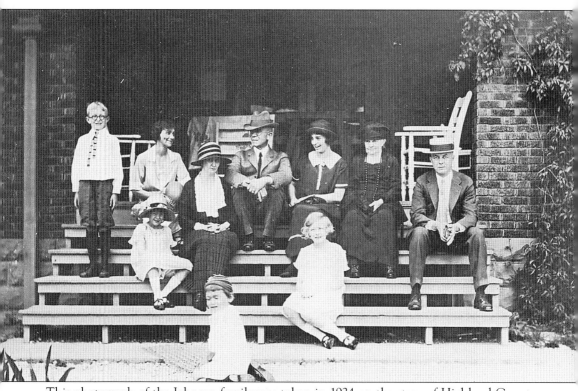

This photograph of the Johnson family was taken in 1924 on the steps of Highland Country Club. Family Members include Bud Johnson (standing on left), Sarah Johnson (young girl with hat seated at left), Sarah Wooliscroft Johnson (seated in middle with striped hat), Louise (Pat) Johnson (eldest child seated in front), and Claude W. Johnson Sr. (seated far right). (Courtesy Bert Thomas.)

Nine

SIGNIFICANT EVENTS AND PERSONALITIES

Robert D. Johnson died a hero in World War I. Robert D. Johnson School is named in honor of this Fort Thomas native. This photograph of Robert D. Johnson (right) at Quantico was taken in 1917. (Courtesy Bert Thomas.)

Robert D. Johnson poses in his uniform on a visit home in Fort Thomas. The little girl is his niece, Louise (Pat) Johnson. (Courtesy Bert Thomas.)

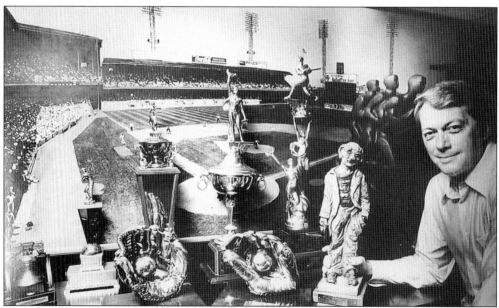

Jim Bunning was a Hall of Fame major-league baseball pitcher with the Detroit Tigers and Philadelphia Phillies. He and his wife and children lived on Winston Hill Road for many years. Today Bunning is a U.S. senator representing the state of Kentucky. (Courtesy Campbell County Historical Society.)

Harlan Hubbard is often referred to as the Henry David Thoreau of Kentucky. He and his wife, Anna, lived on the fringe of the wilderness in Payne Hollow, Kentucky, for over 30 years. Hubbard lived for 20 years in the house he built for his mother in 1923 at 129 Highland Avenue. He lived for two years with his wife in the art studio behind the house. The Hubbards also traveled for six years on a shanty boat to Louisiana. Many paintings by Harlan Hubbard are on display in Behringer-Crawford Museum in Covington. (Courtesy Behringer-Crawford Museum.)

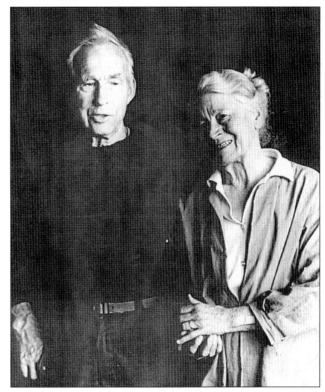

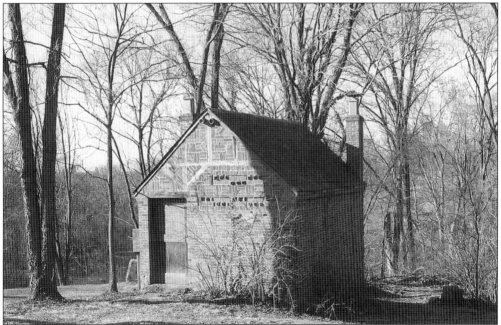

Harlan Hubbard built his art studio behind his home at 129 Highland Avenue in 1938. He and his wife, Anna, lived in the studio for nearly two years after returning from their shanty boat trip to Louisiana. A number of Hubbard's most popular paintings were painted in the studio or on the second floor of his Fort Thomas home.

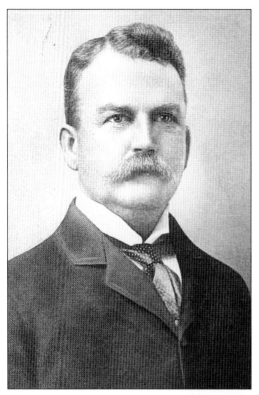

Maj. Samuel Bigstaff was instrumental in locating the Fort Thomas military post in the Highlands in 1887. Bigstaff was a Confederate soldier and a Union prisoner at the Newport Barracks at the age of 17. Bigstaff married the daughter of a prominent Newport attorney who sent him to law school. He rode with Gen. Phil Sheridan when the general selected the site of Fort Thomas. Bigstaff developed most of east Newport and operated the electric streetcar company with tracks that ran from Newport to Fort Thomas.

Henry Schriver stands beside the bronze memorial to the 6th Infantry Regiment. The memorial is located on the west face of the stone water tower at the entrance to Tower Park. Twenty-eight soldiers from Fort Thomas were killed at the Battle of San Juan Hill in Cuba in 1898. Henry Schriver built all of the structures on the military post and the tower. He also built the Avenel Hotel, Highland United Methodist Church, and his home on Manor Lane.

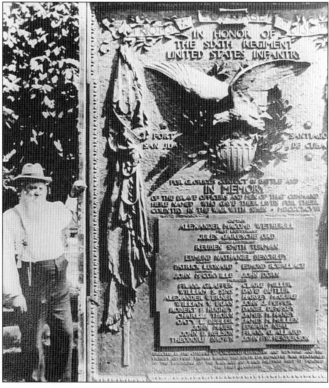

George Ratterman was a star quarterback at Notre Dame and played for the Cleveland Browns. Ratterman also served as sheriff of Campbell County from 1962 through 1965. He ran as a candidate of the "Switch to Honest" Party, the Committee of 500's political arm, in an attempt to stamp out organized gambling in Newport. The Committee of 500 was organized by a group of Fort Thomas businessmen with the goal of running honest candidates for office who were committed to eliminating corruption and mob influence in Newport. During his campaign, mobsters drugged Ratterman and placed him in bed with stripper Juanita Hodges, who was better known as April Flowers. Ratterman was cleared of all charges and went on to win the election with the support of 69 percent of the voters in Fort Thomas. Ratterman currently resides in Denver.

George Ratterman served as sheriff of Campbell County from 1962 to 1965. A native of Cincinnati, Ratterman moved to Fort Thomas after marrying a Fort Thomas native. He played professional football for 10 years and graduated from Chase College of Law. Ratterman worked as a tax and investment counsel for a prominent Cincinnati firm when he agreed to run for sheriff with the backing of Fort Thomas businessmen organized as the Committee of 500.

Congressman Brent Spence represented Fort Thomas in Washington from 1930 to 1962. He served under five presidents. He once held the distinction of being the oldest member ever to serve in the House of Representatives.

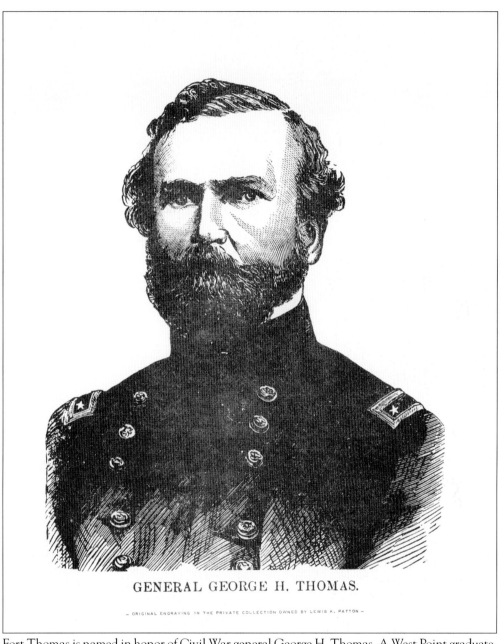

GENERAL GEORGE H. THOMAS.

Fort Thomas is named in honor of Civil War general George H. Thomas. A West Point graduate, Thomas chose to cast his lot with the Union during the Civil War despite growing up in Virginia. Following his defeat of the Confederates at Spring Mill, Kentucky, in 1862, his troops joined Buell's forces and fought at Nashville and Pittsburgh Landing. General Thomas distinguished himself at Murfreesboro and Chickamauga. His gallant stand against twice his numbers won him his nickname, "Rock of Chickamauga." General Thomas fought with William T. Sherman in the 1864 Atlanta campaign. In December 1864, he crushed the Confederate army at Nashville in the most decisive Union victory of the Civil War. Thomas was promoted to major general in the regular army and received a special vote of thanks from Congress. Gen. George Thomas died in 1870.

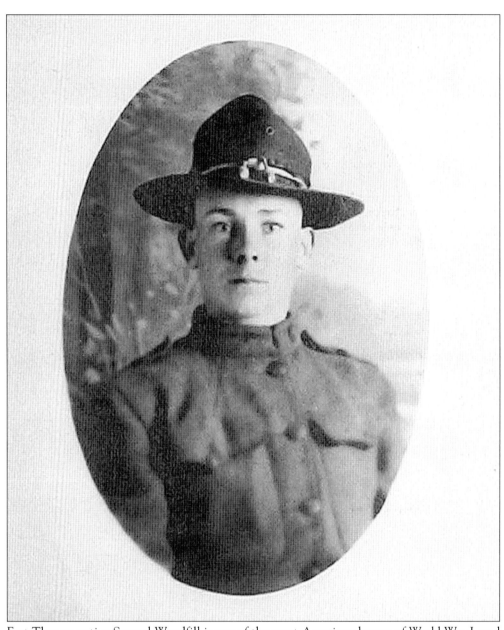

Fort Thomas native Samuel Woodfill is one of the great American heroes of World War I, and Woodfill School is named in his honor. A first lieutenant with the 60th Infantry, Woodfill came under heavy fire while leading his company against the Germans at Cunel, France, in 1918. Woodfill went out ahead of his men toward a machine gun nest and worked his way around its flank. When he got within 10 yards, four of the enemy appeared. Woodfill shot three of them but the fourth rushed him with his gun. After a hand-to-hand struggle, Woodfill killed the German officer with his pistol. Woodfill rushed a second machine gun nest and shot or captured members of the nest. A short time later, Woodfill charged a third machine gun nest and killed five men with his rifle. He then drew his revolver and jumped into the pit when two other gunners turned their guns on him. Failing to kill them with his revolver, he grabbed a pick lying nearby and killed both of them.

Henry Stanbery resided in the north end of Fort Thomas and was a major player in the establishment of the Highlands in 1867. Stanbery served as attorney general of the United States under Pres. Andrew Johnson and played a key role in Johnson's Reconstruction efforts and impeachment battles. He resigned in 1868 to head Johnson's team of defense lawyers. After the Senate acquitted Johnson, the president placed Stanbery's name before them for reappointment as attorney general. The Senate rejected the proposal. Stanbery died in New York City in 1881.

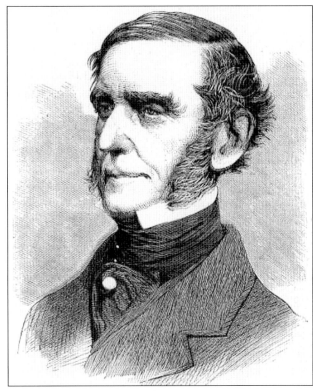

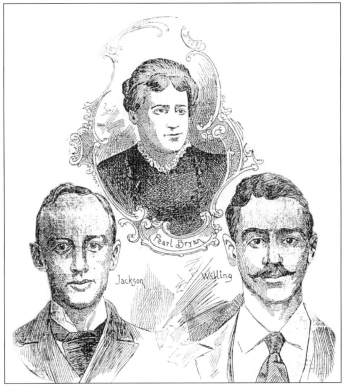

Pearl Bryan's headless body was found by a young boy in a field in the south end of Fort Thomas in 1896. Alonzo Walling and Scott Jackson, two dental students from Cincinnati, were arrested for the murder of the Indiana native. They were offered life sentences instead of death if they would reveal the location of Bryan's head. They refused. Walling and Jackson were hung behind the Newport courthouse on March 21, 1897. This was the last public hanging in Campbell County. The murder of Pearl Bryan brought national attention to Fort Thomas.

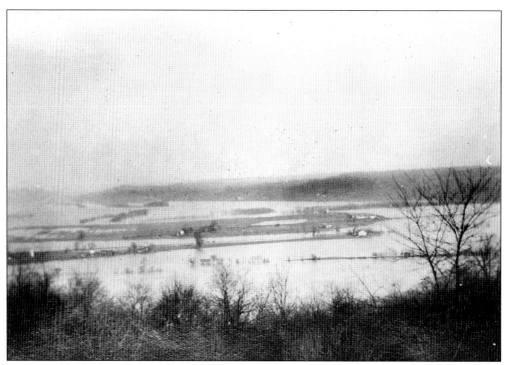

Extensive flooding took place when the Ohio River went over its banks in 1927. This photograph was taken from the end of Oak Ridge Street. (Courtesy Bert Thomas.)

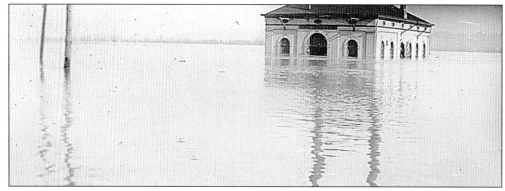

The great flood of 1937 engulfed the water pump house along the Ohio River on Route 8. The flood caused considerable damage and loss of life in the Greater Cincinnati area.

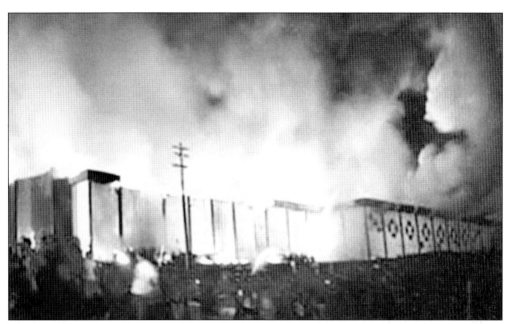

The fire at Beverly Hills Supper Club in Southgate killed 165 people in 1977. A number of Fort Thomas residents were in the club at the time of the fire, but all made it to safety before being overcome by smoke or fire.

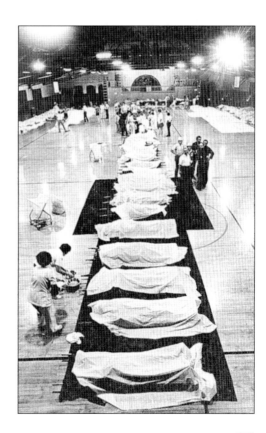

The Armory building in Tower Park was converted into a makeshift morgue after the fire at Beverly Hills Supper Club.

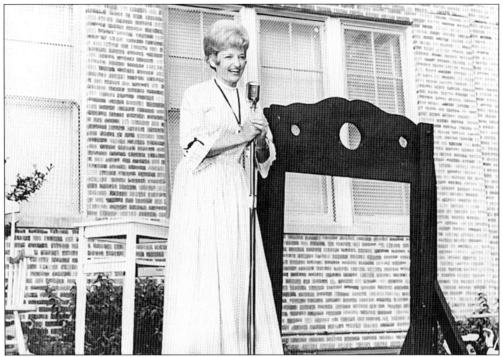

Jackie Thompson performs at the Fort Thomas Centennial Celebration in June 1967. Thompson was at St. Thomas School. (Courtesy Dick Thompson.)

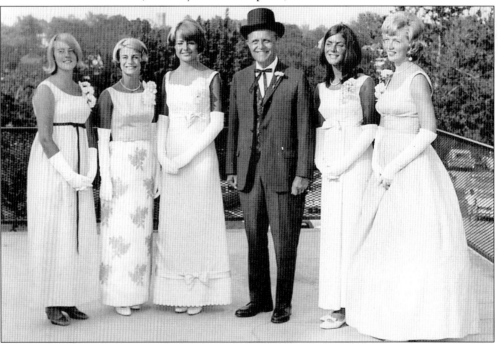

Gov. Ned Breathitt poses with Fort Thomas Centennial beauty queen candidates in 1967. Queen Bunny Wight is on the far left in the photograph. Other candidates included Donna Jo Dudderer (second from left), Pam Kuhnhein (second from right), and Laura Pogue (right).

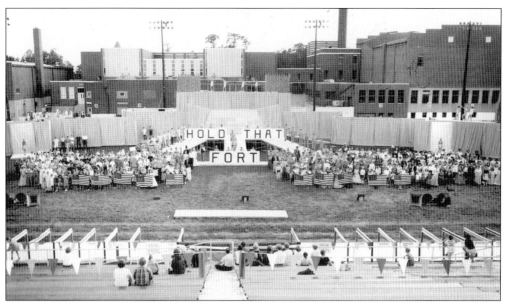

"Hold that Fort" was the theme of the big performance at the Fort Thomas Centennial Celebration on the football field at Highlands High School in 1967. This photograph was taken at a rehearsal a few days before the actual performance.

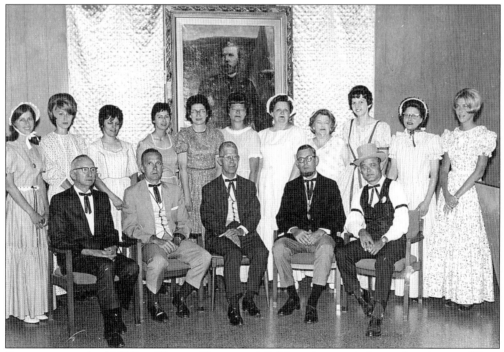

Participants in the 1967 Fort Thomas Centennial Celebration pose in front of a painting of Gen. George Thomas.

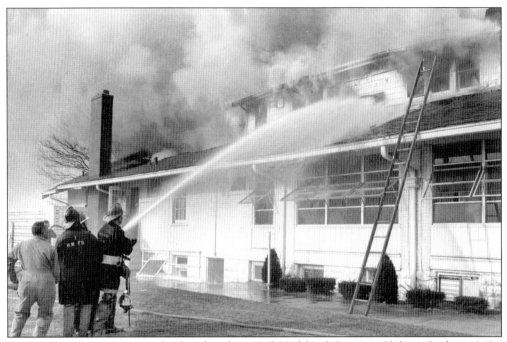

Firefighters attempt to control a fire that destroyed Highland Country Club in the late 1960s. The building had to be torn down and a new clubhouse constructed. (Courtesy Kenton County Public Library.)

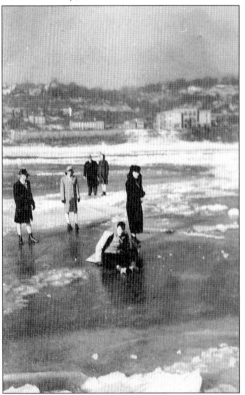

A number of Fort Thomas residents braved the cold to have fun on the ice when the Ohio River froze in 1937. Evelyn Thomas is sitting on the ice after taking a spill. Tay Chase and his wife are in the far background.